Art Is Action

Art Is Action

A DISCUSSION OF NINE ARTS

IN A MODERN WORLD

By

Baker Brownell

KENNIKAT PRESS
Port Washington, N. Y./London

ART IS ACTION

Copyright, 1939, by Harper & Brothers
Reissued in 1972 by Kennikat Press
by arrangement with Harper & Row, Publishers, Inc.
Library of Congress Catalog Card No: 72-183136
ISBN 0-8046-1690-6

Manufactured by Taylor Publishing Company Dallas, Texas

ESSAY AND GENERAL LITERATURE INDEX REPRINT SERIES

Contents

Introduction

THIS book says that art is a natural kind of behavior and that the so-called "fine arts" are more of a burden than they are worth. It says that art is human action —always action, always in action—never the fixed and final structures called works of art. Art from this point of view is action that is immediate in value and at the same time functionally significant in the whole pattern of living.

Art is thus a union of production and consumption. It has form, but the content and action of it are more important. Art indeed is folk art, not fine art.

The book traces the interwoven course of fine art and folk art in the modern world and tries to evaluate it from the point of view of human integrity and delight.

Chicago April 19, 1939

I. The Point of View

I SHALL orient these rash words about art by giving here a catalogue of assumptions. It may be read now before the book begins, or after the book is finished, or not at all. In any case the book will have to stand as best it can on its own feet. Nevertheless all statement starts from assumptions. Here are some of mine. ⌐Art arises in those strange complexities of action that are called human beings. It is a kind of human behavior. As such it is not magic, except as human beings are magical. Nor is it concerned in absolutes, eternities, "forms," beyond those that may reside in the context of the human being and be subject to his vicissitudes. Art is not an inner state of consciousness, whatever that may mean. Neither is it essentially a supreme form of communication. Art is human behavior, and its values are contained in human behavior⌐ What kind of human behavior will be discussed later.

Human behavior has two centers of organization. One of them is the human body, of which there are now more than two billions on the earth. From this physical organism emerge the activities of men, and upon it, or in reference to it, most of these activities are directed. This pattern of behavior is the indi-

vidual. It is a contour of activities with reference to
the body. And if this seems too crude, I ask what else
is the individual? Even Thomas Aquinas said that
the physical body in this life and the regenerated,
immortal body hereafter is the individuating prin-
ciple in human beings.

The other center of human behavior is called so-
ciety. And society, I assume, is the behavior of indi-
viduals in reference to each other. Unlike the indi-
vidual, society has no body. Neither has it that
nervous and symbolic unity of organization that often
is called consciousness. Sometimes, to be sure, it is
stuffed by its admirers with existence, entity, or what
have you, as if it were an operating unit in itself. In
the same way the individual sometimes is promoted
metaphysically to the "self" and becomes an equally
stuffed reality of some sort over and above and inde-
pendent of the behavior of the human being con-
cerned. These stuffings and hypostasizations I shall
try to ignore.

But society, even as the simple behavior of human
beings in reference to each other, is important. It is
a focus of organization of men's behavior. It is a
center of living activity coordinate with that other
center called the individual. As a fact the individual
and society are reciprocal patterns of behavior. They

mean little without each other. The content of individual activities is largely social. A man's world, from language to sex, is in great part concerned with other people. And the content and context of societies are individual human beings. Both the individual and society are complexes of human activities. The difference between them is their point of reference.

These activities are the basic data in my discussion of art. They take place; they boil and spatter in millions of forms and elaborations. They rise and fall in their infinite rhythms like waves on the sea. These human events are sometimes thrown into social, sometimes individual patterns. The difference is not great. Perhaps it is not even important.

⌐Art is mostly individual activity.⌐ I am aware of the social and communicative functions of art, but I think these are secondary. I am aware too of group activities in the arts such as dancing, the drama, the orchestra, choral singing. And these are not secondary, but of the greatest importance. I assume, nevertheless, that the motive of most artistic action is individual, not social. And I assume that the value of art is usually in the individual type of activity even when it is concerted with others. But in this I may be wrong.

If need be, I will waive the point. It is not of

critical importance from my point of view. I hold only that art, and its objectified correlate, beauty, is involved in behavior. Whatever art and the works of art may be, whether social or individual, does not affect the issue; in either case they will have in them the mark, the structure and the unique quality of human action.

What is action? Concrete action within the frame of space and time may have several definitions. Aristotle called it variation according to rule. A more modern but less articulate and classical way of putting it is to give to action the central importance of things. From this point of view the state of a thing before and the state after action will be treated as merely perceptual termini, or abstract pauses in action, that arise largely because our experience moves in little jumps. Activity here is central, while static things are more or less artificial projections that give us points of reference and organization in the world. Action thus is everything; it is a concrete expression of energy. It is relative in character. Time is a method of measuring it. This, I know, answers no questions, but it indicates a point of view.

Living action is functional. I am not sure that it is more functional than any other kind of action, but we like to think so. We are more aware of its function.

We value the living process. We find it intrinsically interesting and because of this interest we give vivid emphasis to the functions of our activity. In this native interest in living are the sources of all value. We attain there a primitive identification of all our powers. Values emerge, or are created. They are mystical, I think, but I shall carry this no further. Mystical talk is hardly relevant here, and usually is repugnant to the contemporary type of mind. In any case the function and consequence of human behavior are noted and considered because life is interesting. In all organic life action is teleological. The consequence of action enters into its original structure and, though it may not be conscious or purposive, it is no less teleological.

Living action also is rhythmic. It moves, as William James might say, by flights and perchings, or as George H. Mead would say, in three stages, perception, manipulation, consummation. Living is rhythmic. It is an order of tensions and relaxations. It is muscular in nature, and the rhythm of muscular movement pervades all living works.

I have thus far assumed that living activity is the primary point in all interest and value, that it is functional, teleological, rhythmic, and that it is muscular in its pattern and program, if not always mus-

cular in fact. Now, what about human action, and what kinds are there?

There are three kinds of human activity, the nutritive, the external, the symbolic. This is a large and heavy statement that needs more amplification than I can give it here. I refer, however, to the inner, automatic processes of nutrition, growth, reproduction, metabolism, to the external and dynamic activities of man as a discursive animal, and to the processes, often called mental, of using and manipulating symbols. The three kinds of activity are of course inextricably related to each other. Nevertheless, there is profit in considering them separately.

As a set of nutritive activities a man is primarily an alimentary tube with various associated organs and agencies. Through this tube flows a stream of alimony. Some of it is absorbed into the system and is transformed into bodily substance in a continuous process of give and take. The relative equilibrium of these processes is life. Growth, reproduction, natural death are functions of this continuous process. In any particular human or other animal this process is only a part of the general nutritive activity of all living things. It has the same source as all other living things and is, indeed, the same process. In nutritive terms all living things, past and present, may be

considered one massive, colloidal stuff in the process
of change. Life has nutritive unity.

But life has dynamic multiplicity. As a discursive
animal, man is not one mass and action, but is dis-
tributed in a plurality of units called individuals.
This distribution makes possible, no doubt, a larger
area of absorption surface in relation to the volume
of living protoplasm. It also furnishes greater op-
portunity for food, fertilization and other services.
Muscles and muscular activity characterize this dy-
namic aspect of living things. The overt activities of
men, from hunting rabbits to playing Kelly pool,
are muscular and express the nature of muscles in
their forms. The senses, the nervous system, the bones
and other parts of our structure have their place,
but the character of our action is mostly muscular.

Even thought, which is the complex organization
of little, substitute activities, or symbols, in place of
overt, external activities, has its muscular com-
plexion. It is adjusted to the muscular rhythm of
tension and relaxation, tension and relaxation. It
never is sustained. For an animal without a muscular
system, an animal, let us say, which performed its
activities by means of a hydraulic system, like a bar-
ber's chair, all thinking as we know it would be
irrelevant and worthless. I shall discuss both sym-

bolic activity and overt activity in a later part of this book. Here it is enough to say that the muscular mechanism gives its character not only to all sorts of overt activities but to our symbolic activities as well.

The arts are primarily overt, muscular activities. Some of them, however, are also deeply involved in symbolization. But questions of art bring in questions of value. I must therefore list briefly some more of my assumptions as to value.

The activities of human beings in terms of function, interest and value may be considered from two points of view. An activity may be valued for what it accomplishes beyond the activity itself. Or the activity may be valued in terms of the immediate interest in the activity itself. The one is called instrumental, practical, or productive. The other is called enjoyable, consummatory, or consumptive. It is intrinsic value. In natural life these two kinds of valued activities seem to be always combined. Separation of them is hostile to the natural situation. And in man, too, they are combined in his more integrated moments of living. Nevertheless, the greater part of man's civilized activities are sharply separated in this respect. The modern world is marked by the great cleavage between production and consumption.

The arts are activities for their own sake. When

they incorporate in these intrinsic activities production as well as consumption in organic, gracious form, they are at their best. They unify the two, when natural unity for one reason or another has broken down. Art is this activity, immediate in value. I do not know how to expound it. I doubt if it can be done.

This immediacy of value is profound, as profound as laughter, as profound as the thrill of skating or the dance. It involves the direct interest that a man has in living. He participates in living, discovers it, is submerged in it. He becomes unified, in a way that I would call mystical, with action and value. Value, as I see it, resides in concrete action here and now. It is an identification in that immediate action.

I have made here a number of statements that I have called assumptions. Really they are not assumptions, not all of them, but condensations. I have elaborated them to some extent elsewhere. In this book on art as action they are needful perhaps as a statement of point of view, a prolegomenon; beyond that they may be ignored.

The fate of a book that deals with, not one, but a dozen arts, and then indiscreetly, can well be a sad one. In this book I make no pretense to know all the literatures, all the tunes, pictures, dances, dishes,

buildings, dramas, skills and arts that are relevant to the subject. Nor do I know all the philosophers and philosophies, the psychologies and physiologies that are no doubt a proper background to my theme. On the other hand I have experience, I live, I am a part of that complex of activities that is the human race. Perhaps this is also relevant. It is not unusual, I know, nor highly special, but it seems to me about the most important background for the arts.

The book is similar to some modern, American music. It is done with less concern for the classical manner, the correct note, tone, reference, and with more concern for the values of improvisation, play and free expression. Factual scholarship has its place, and so also has the imagination. I have tried to write a book that is consistent in its method with its theme.

II. Muscular Conditions of Life and Culture

THE shape of action and the limitations of a man's travels are determined by his physiological structure. His two-leggedness, his grasping hands, his rolling eyes and head, his weight and muscular developments are more involved in his activities and institutions than can well be estimated. A man's activities in the outer world are expressions of his physiological apparatus. His actions as it were are two-legged and weigh twelve stone, for his physiology is in them.

As an acting animal, a man is a tubular structure with two pairs of matched appendages called limbs. These are levers in principle and are operated by the contraction of certain tissues called muscles. Muscular contraction in association with the lever gives the whole structure its mobility. Since his action is not random but is related systematically both to his inner organic processes and to activities of the things about him, it may be assumed that an agency for integrating his discursive activity with his nutritive processes and with things beyond his physiological periphery, will be necessary. This is mainly the nervous system. It is a specialized method of coordinating inner activity, outer activity and the activities

in the environment. In its more complex phases this coordinating activity is called thinking. That, however, is a lesser function in the field.

The ability of many living things to contract certain tissues and then to relax them makes them mobile. It is much elaborated and specialized in so-called higher forms, but all of our movements come down to this. Our discursive activity, going to the post office, cranking the car, playing the flute, shooting a wild turkey, are contractions of these tissues and have in their structure the character of muscular contractions through and through them. So universal is this mode of movement in the living world that we are likely to forget how special is its technique and how limited in kind its activities are. Suppose for example that the movements of living things were obtained by some hydraulic method, corresponding to the hydraulic press or the hydraulic ram, instead of by tissue contraction and relaxation. Our field of activities would be entirely different. The forms of action would be different. The physiological instruments for action, the body, would be different. The activities and external relationships which we now know would be an alien universe. Pressure tanks and plungers, little tubes would be the mode. A man would rise from his bed, no doubt, much as an automobile rises on a hydraulic stem for oiling.

Or suppose the mobility of living things were ob-
tained by gaseous expansion. A man would grow
cylinders, perhaps, in which his organs would secrete
explosive gas, to be touched off by some vital spark
into action. The gasoline motor or the gun have
means for getting motion that living things conceiv-
ably might have.

It is clear, indeed, that the particular mechanism
for giving mobility to living things, namely muscular
contraction, gives its character to our entire active
world. We are muscular animals with specifically
muscular activities. What the inner structure of the
activity may be is not entirely known. It is nervously
controlled in various ways and this control is con-
tinuous. Without continuous nervous impulse the
muscle loses tonus and soon dies.

Muscular life, indeed, is a continuous state of ten-
sion, in which changes take place with more move-
ment or less, but the tension never disappears. Mus-
cular activity is not, in other words, spasmodic action
with quiescence in-between. It is a continuous tonus
with relative extremes of rigidity and relaxation.
This variability in tonus results in variable action.
The come and go of active life resides here. The ac-
tion and repose of the day's work, in contrast to the
continuous movement of such systems as the cours-
ing blood, find their key in this roughly rhythmic

variability of muscular contraction. But underlying these ups and downs of muscular activity is a continuous possibility of movement inherent in the living tonus of the muscular system.

A man lives among variable and highly diversified things that impose on him uneven demands for action. His type of activity in turn is selective to some extent of the environment that he has. With an apparatus that expressed its energy in a smooth, continuous flow, like a steam turbine, he would find himself unable to meet these variable requirements. He would need to live in another type of environmental world, or live not at all. Were his activities like those of a steam turbine, he would overdo while in the trough and be too weak to take the peak of the load put on him.

A man's ability to express his energies and actions in variable quantities and in diversified forms is characteristic of many, if not all, of the kinds of living things that are considered well advanced. Later, through methods of activity called thinking, this variability and diversification of action is again greatly increased. But thinking would have no value were not the muscular system built to make variable movements. The basic patterns of thinking, the variability, the easy flights, the here and there, the

continuous shift of focus and attention, are coordinated with the muscular patterns of activity that preceded them in life's development. They take their cue from the muscles and the type of activity that the muscles impose on us. Thinking is an extension of the forms and functions of muscular activity, or largely so.

Sense and Action

But muscles in action are not all of physiology, nor do they give us the complete structure of the active world. Such things, for example, as bones have their part. The senses, with their limitations and ranges of contact with the activities within and without our bodies, lay down great avenues for us to travel through the world. We are limited to those avenues, or nearly so. The sense of sight, for example, responds only to a narrow band of wave lengths of light. The ear responds only within other narrow vibratory limits. The senses establish limits to our active response. They too have their part in the form and content of our action.

A man's response to vibratory activities extends the periphery of his life far beyond the skin that covers his alimentary tube and locomotive organs. His more important senses, so far as this larger world is concerned, are sight, or light vibrations, sound or vibrations in fluids or solids, smell, probably molecular vibrations. His temperature sense can vaguely gather experience from heat vibrations from a distance, but this is not much more discriminating than, say, the sense of sight in a starfish. His tactile apparatus is sometimes sensitive to vibrations in solids or even in air up to and including sound. But without eyes, ears, or nose, man's periphery would contract down to his skin, or near it, and like an angleworm's, his world would be only what he immediately is burrowing in. His muscular system with its discursive facility and variable power would be next to useless. His thinking activity in such a world would be alien in its pattern and almost entirely meaningless. A worm could not use a good brain if he had one. A man so limited in sense apparatus would need little more than his spinal cord, and not all of that. These senses of the body and these bodily muscles establish the world in which man lives. They draw its limits, define it, and mental activity, so-called, without a body, or a personality abstracted from

physical structure, are as meaningless as a horseback
ride without a horse or maternity without a mother.
The senses define the range as the muscles define the
form of our activities. And even in modern times
where instruments extend the range into longer radio
vibrations or into shorter ultraviolets, it becomes in-
telligible only when translated into the sense pat-
terns that we know.

Our outer range for that matter is not great, as
such things go. Limited to a few vibrations in fluids
and solids and to narrow bands in the electro-
magnetic field, and possibly, but only possibly, to
some other form of contact called extra-sensory per-
ception, we miss no doubt nine-tenths of the activi-
ties about us. Our usual assumption that contact
with things at a distance must be through vibratory
or possibly projective phenomena of some sort, such
as light or sound, is itself based on a naïve acceptance
of the limitations of the senses. Gravity, for example,
may not be a vibratory phenomenon, probably is not,
and still is a form of contact and dynamic relation-
ship with things at a distance. Movement through
space, electrical fields, even distance itself, may be
types of relationship or contact which we place in a
different order from light and sound because our
senses have no direct way of experiencing them. I

am not suggesting that they are vibratory or anything analogous to vibratory phenomena. I merely say that the world that we observe, including even that of the scientist, and the activities that we perform are limited greatly by our capacities to observe and to perform.

In the field of outer activities our senses are instruments of our capacity for being affected by things, while our muscles are instruments of our capacity for affecting things. Though I have treated the two separately for purposes of analysis, they really never should be thought of separately. They are two phases of one activity. They are a single pattern of action. They are functionally and dynamically one and are meaningless without each other. It is unfortunate that so much work in psychology, philosophy and aesthetics has been done on the assumption that sense activity and thinking activity have somehow a status, law and value in themselves divorced from muscular action. Such work, whether it be called epistemology or fine art, can be little more than a fluttering in a vacuum. Only in the whole living pattern can these fragments and specialties have significance.

The muscles then, the senses, the whole physiological apparatus of man define to a great extent the form and content of his world of activities. If the in-

dividual is fundamentally his behavior, it is clear that the total activity of this nuclear unit in the living process, called a separate creature, is the individual. And physiological action must in no case be segregated from other aspects of his action. It is there, through and through, from the variability of muscular contraction to our vibratory contacts through the senses. It is there and will remain there. What else the individual may be always is involved in this physiological texture of life.

III. Art

THE arts are long, as poets have said, and frail space and fleeting time do not easily contain them. Arts are activities—at least I shall take that as a primary thesis —but they are varied. They incorporate many kinds of activity. To place them definitely in an organic pattern is hard, if not impossible.

⌊The arts, particularly the formal arts such as literature and painting, are deeply involved in symbols.⌉ As such they would belong, it would seem, in the field of thinking activities. They cannot be considered without entering this field. But the arts also, and I think primarily, are direct, overt action. As activities of this sort they belong in the rhythmic, dynamic field of living. Their value lies in activity itself. Art, as Havelock Ellis would say, is practice.

I would like to deal less with the fine arts, those professional, highly evolved specialties in sound, color, words, or other medium, and consider more the folk arts, for they are nearer the spirit. Better still I would like to study, not arts at all so far as they are fixed formulations and methods of expression, but the casual expressiveness and beauty of action in the life of folks as they go about their worlds. These

gestures of beauty, these moments of illumination in life as it goes along are more profound and valuable than the fine arts all put together.

But this is hard to do. A book is condensed, artificial. The open, casual texture of life is too loose a weave to hold it. A book falls through the mesh of reality. To report these lives and arts distorts them. The barefooted Tahitian girl comes from the door of her bamboo bungalow with an empty pitcher in her hand. She steps down from the porch and walks across the grass to get water. What book, or for that matter, what poem can report the simple tune and beauty of it? It is not for books.

I find myself turning almost inevitably to the organized arts, for they can be talked about. But what cannot be said is sweeter. Things lose directness when they are talked about. Objectification countermands the mystical beauty of living action.

Mr. J. C. Williams has sawdust in his thin gray hair, yellow cypress dust, also a touch of mahogany. The cypress came from the shelving at the Hendry house, the mahogany from the bench saw this morning as he cut a strip of the red, deep wood for repairs on a china cabinet. J. C. has a little shop set in the middle of the Perry Lumber Company yards east of town. He is expert. His shop is filled with work

waiting from Stuckey's furniture store and from householders of the town.

"It's hard to keep up with them," he says, looking over his dusty spectacles, "you can't hurry this work, and you can't go too slow either. It just about sets its own pace." He is sanding down a well-turned table leg. The dust, so fine that it is only a smell, an acrid sweetness of wood, sifts out invisibly into the air. He buffles off the last roughness and lays the leg endways on a shelf to wait for stain and varnish.

"Now I'll cut some pieces for the spindles of the armchair over there. And then we can go for something to eat. It's close to noon."

He takes down from a shelf, on which are arranged a number of pieces of different woods, the block of treasured mahogany. He goes to the armchair for a brief measurement or two. With his rule and pencil he makes careful lines on the mahogany. He trips the belt onto the small bench saw and switches on the motor. The hum and clatter of the motor and belt are soon caught in the fierce crescendo of the saw.

"You have to be a little careful with a saw like this when you're cutting small."

He fingers the wood delicately, gives it an exact set on the steel bench and lays it against the saw. The sound of the saw spurts up bitterly as the teeth take hold. The wood moves in; Williams' arms sweep

through. They move with a controlled gesture and rhythm that ascends with the sound, slows again while the song jets higher, drops and returns as the saw cuts through the wood with a last metallic clang.

Five spindles are done, five verses of the song. This many times his arms repeat the delicate dance and measure of the bench saw. The red dust flies in the air. It floats out in the room, settles down in Williams' thin hair.

"That's done," says J. C., "I'll turn them this afternoon."

And this sort of thing, it seems to me, is unique in the world. Though repeated endlessly wherever men are, though found in the thousands of human activities, the skills, the crafts, the natural gestures of life, each bit is unique in interest. It has this value first of all to J. C., himself, a direct value in activity that is more important than all the communicative arts. But it also communicates something of its value to another looking on. Though he is not, like J. C., the valued activity, he can sometimes recognize its beauty. This, no doubt, is the simple basis of all the arts so far as they are communicative. They are substitute experiences, often they are symbols, in which the onlooker in turn finds a direct, though often modified, value.

More primitive and far more important is a

man's direct identification in activities. He is his action. This is the primary stuff of the arts and of all values. Williams finds value in the sweep of his arms across the bench or in watching a storm come up from the south. His values are directly in his activities. Though the completed work of art, which in this case is the spindle, may be unfortunately banal, imitative and uninteresting as a finished design, the loving activity of Williams in making it has an intimate and ultimate value that can not be denied. This is central in all art. It is action. The completed work of art is secondary to this activity. Communication is also secondary. The arts I think are really less communicative than suggestive. They fire other folk, ignite the inherent activities and the values in other people rather than translate or transport them. But they are, even so, roughly communicative.

Expression

Expression is essentially this. For an expressive activity gives form to an unrealized situation in the

person who is acting. It gives articulate being to what was implicit there. It is creative. But expressive activity also gives form to an unrealized situation for others who do not initiate it. It establishes values in articulate patterns of reality both for the poet and his audience. If the audience is less creative than the poet, it finds a value in recognition and secondary activity. Happily the people of the audience are not dependent on formal art. They also are creative. In the more elemental arts, or foundations of art, they do not lack. In their activities themselves, men find their most important art.

Blaine Bradley is going to wash his dog. The dog is a bull terrier, purebred, powerful, and white as the shell sand on the beach. Blaine, on the other hand, is a freckled-faced boy of twelve whose blue overalls and bare feet may be seen almost any day scampering down the grass-grown road past old Lonnie's cabin towards the fishing hole under the mangroves. He is in junior high school where he does well enough. But his dog and twenty-two calibre rifle are his real responsibilities.

Because the dog, Tim, runs in woods with Blaine he gathers ticks. Small ticks and big ones, from pinheads to shoe buttons, bury their heads in his hide. They spread over him moving from a focal center.

Eating, breeding, moving on in mass migrations over the canine continent, they soon pre-empt all the available feeding grounds. Only washing with a tick-icide can conquer them. Every week Blaine washes his dog in the long battle.

A basin of water is warming on the stove, and Blaine calls the dog to him. He puts a clear salve in the small black eyes to prevent irritation from the wash. This is tragic portent. The dog has learned the preliminary smells and movements. His tail drops. He retreats to a far corner under the seat on the porch.

The water is warm. Blaine gets the brush. He pours an ounce and one half from a bottle of dark, syrupy liquid that Dr. LaSeur gave him. One ounce for fleas, he said, one and one half for ticks. The boy pours it out carefully into the warm water. It coils down in dark vermicular forms on the bottom of the pan. An evil-looking greenish haze envelops it and merges with the water. A red and twisted smell like lysol hangs over it. Blaine stirs the liquid to a yellow milk consistency and takes it to the back steps.

"Come Tim!" But Tim remains hidden under the bench. "Come here. Come right here." Tim crawls a few feet, stops. He comes no farther. Blaine goes to the bench, captures a hind leg and pulls Tim out.

He carries him, fifty pounds or more, to the back steps. "Now lie right there," he says.

The dog huddles down, his power quenched. He is a massive beast, with broad short back and a mighty brisket. His legs, set wide, are muscled for sudden power. To dogs his great teeth and speed are terror. He fights with ferocity and serious dispatch, and no dog is left without a broken back or a throat torn open. But towards men, and particularly Blaine, he is gentleness itself. It is a clumsy gentleness, to be sure, not unlike a cow's as he tries to sit in the boy's lap.

Now he is a sorry sight. The fighting dog hates water. His great head droops. His tail curves in between his legs. As the water touches him he quivers. He stands drooping on his four legs. His sides shiver as Blaine soaks him with the warm medicated water. The bath starts at the dog's hind end, where the pests are likely to be most persistent, and rubs forward against the hair. Then the boy turns the dog around and works from the front end back.

When the dog is well soaked and scrubbed, the boy leads him indoors to prevent his rolling wet in the dirt. Blaine gives him a fig newton and turns him loose. The dog shakes. Great shakes begin at the head and move progressively towards the tail.

He barks with excitement, turns and plunges through the house. He slides on the rugs across each room. He races from one door across the house to the other door, turns and races back. He skids around the corners. Rugs fly. Chairs clatter as he side swipes them. The music stand falls with a crash.

Then the small climax is over. Tim gets another fig newton, seats himself in the sun. Blaine rinses off the back steps, washes the pan, straightens the rugs, carefully puts the music stand back where it belongs. Fortunately no one else is home.

Washing the dog has its drama and artistic consequence. It has its own interest. Though given place in a larger pattern of activities by its practical instrumentality in getting the ticks off Tim, it has, in organic relation with this, its own significance and form. Life, or at least a good life, is a balance of this immediate value and instrumental value of action. It is a close cycle. It is in the simplest sense art in life.

Though the arts, as they evolve technically towards glittering complexities called fine arts, become more and more symbolized in their activities, more tense, more implicit, as contrasted with the open simplicity of washing a dog, their eventual value is the same. They are activities interesting in them-

selves. They are activities in which primary feeling and value remain in the concrete action and are accepted as formulating influences in the pattern of the act. The arts essentially are no more than this. Washing a dog, as Blaine does it, is no less.

The "finer" arts, it is true, carry activity into more and more remote symbolizations. Implicit action assumes a larger place. Consciousness, whatever that may mean, and segregated perceptions usurp more largely the place of the simple movement and dynamics of life. But in the long run activity is what is valued, or it is not art. Art matures. It is the formal elaboration of activity, complete in its own pattern. It is a cosmos of its own. Art is an extension of that aspect of all organic action that is called final.

Nevertheless, I would be rather drastic about completed "works" of art in contrast to the activity of art. "Works" of art too often become substitutes for the action of art in those who contemplate them. These "works" gather huge and false prestige and the so-called vicarious artistic activity of those who come to their shrines is usually little more than static perception and a few most inactive sentimentalities. I would like to see "works" of fine art such as now fill our museums and concert halls quietly evaporate a few weeks after they are produced. They would

not then stultify by their authority and prestige the native art and action in their vicinage.

This I admit is rather extreme. I probably would not really welcome such destruction. I do insist however that "works" of art on exhibition for outsiders have little to do with art. Looking at them or listening is no more art than looking at a pleasant landscape, for art is a complete cycle of action, productive, consummatory, valued for the activity itself. I will agree, however, that "works" of art may have educative value. They are lessons of a master. They may help us to enrich and formulate experience and to make action more worth while. But unless our own action in itself has a direct value there is no art.

Art Is Action

Though the action of art is a natural synthesis of productive and consummatory value, it is appreciatively final. Art, I mean to say, is enjoyed in itself, and though I would not at all favor the well-worn doctrine of "art for art's sake," I still think that the value of artistic activity is within the activity itself.

It is a direct and primitive presence of activity. It is a concrete whole, a living moment, that I have called mystical.

The critic may say that such a primitive fusion is just nothing at all. In reply I ask only that he turn and see for himself. The immediate moment of living is all that he, or anyone else, has. What it is I do not know. But I am sure that it is not academically divided into perception, will, feeling, knowledge. The immediate moment of living is action, indeed, but action involved in value. It is action involved in interest. It is, indeed, interested action. This primitive integrity of action and value is the spring of art.

Form is the inner structure of artistic action. It is the rhythmic closure of consummatory activity which, unlike the practical, never depends on ulterior ends beyond its own pattern. It is final in itself. The difference between art and the practical is thus the difference between a closed or rhythmic pattern and an open one. Art, I suggest, is involved in the basic rhythm of individual life. It is identified with that beat of the living process by which individual units are articulated. It is perhaps literally a living rhythm.

But the arts are more than individual in significance. A critic such as Faure, indeed, sees in the elaboration of artistic forms a continuous inner

flowering and development that is mystically consistent with social growth and change. Until architecture had reached its final form, sculpture could not develop. Until sculpture had matured, painting could not be born. Until painting reached its height, music must wait for growth. All of them are expressive of social change. In early art, indeed, individual significance was unknown.

Of Hellenic society in the eighth century B. C., Faure says, "Not only the individual does not exist, but his existence would be contrary to the very conception of the home, which is perhaps the nucleus, perhaps the contraction of the city, in any case forming with it an indissoluble organism from which nothing can be taken away without ruining one or the other."[1] In such a world art, like all else that is human, is social in significance. It is largely a social expression. But this does not alter the fact that it resides in individuals, is enjoyed by them, and is expressed through the activities of individuals singly or in groups.

If art is long, however, discussion as to the nature of art is endless. Nor is it worth the time. At best the conclusions, if any, are secondary and more or less futile. Art, indeed, may be many things and have

[1] Elie Faure, *History of Art*, Vol. 5, *The Spirit of the Forms* (New York: Garden City Publishing Co., 1937).

many sanctions, as philosophers such as Max East-man[2] suggest. Or it may be not commensurable with conceptual structures. In that case an interpretation of it in terms of rational philosophy may be beside the point and meaningless. We should approach art, indeed, as the artist approaches it, not as something to know but something to do, not as something to think out but as something to participate in.

Art is appreciative activity. It is action in which we find inherent enjoyment, and the best way to get at it is doing what we enjoy. This alone, I admit, will probably produce more bridge games and drinking bouts than works of art, at least in our distorted society. It will produce play and recreation, games, athletics, hunting, fishing, gossip and kissing, music and dancing and home hobbies from burnt leather to gardening. Though the "arts" are more maturely formulated than these enjoyable activities scattered here and there, the essential thing in all is the same, activity for the fun of it. Artists and critics in these modern sophisticated days should not forget that.

[2] Max Eastman, *Art and the Life of Action* (New York: Alfred A. Knopf, 1934).

Play

And for that matter play is a kind of random art. A game has its pattern and crisis and its rhythmic return. A game establishes a play cosmos. It invents a universe. Within it we immerse ourselves as long as we continue playing.

Play is a prelude to art. All enjoyable activities may move on and merge into art. They lose their random willfulness as they mature and establish forms and inner disciplines. And by enjoyment I mean not necessarily pleasure but the inherent value and immediacy in actions, whatever that may be. Play is such enjoyment. It may be serious. It may be even painful, but in any case it is activity for its own sake. Unfortunately in modern times play has been set aside as a speciality for children and for resting people. It has been deprived of its significance and detached from the more functional and important activities of our lives. It must be light, it must be frivolous, we think, or its grace and charm are lost. But play is a primary aspect of activity that should pervade all life. It underlies imagination. It is interesting activity. Play, in other words, is a free tendency of action to take forms that express that interest in activity itself. As such it should be a part of all work, and in a better world it would be.

Play, indeed, is closely involved in workmanship. Were it not for man's invincible playfulness the practical schedules and motivations of the modern world could not amount to much. Men like to give their activities good form, they like to do a good job simply because an active operation in itself is worth doing well. Thus the work of this distorted world somehow goes on. This enjoyment in work has been variously subdivided and analyzed. De Man,[3] for example, gives what he calls the instincts of activity, of play, of construction, of curiosity, of self-assertion, of possession, or the worker's identification with his tools, and the instinct of combat as primary motives in joy in work. But play comprehends most of the others. It is deep in workmanship. It goes farther than any other kind of activity, I think, into the primitive sources of our intrinsic interests.

Play is a primeval activity in which enjoyment is inherent. I have called it a prelude to art. Since it is more fundamental than the arts, perhaps it were better to say that art is a postscript to play. In any case play, love, art, laughter, religion are alike.

O ah drove three mules foh Gawge McVane
An' ah drove them three mules on a chain

[3] Henri De Man, *Joy in Work* (New York: Henry Holt & Company, 1929).

Nigh one Jude, an' de middle one Jane,
An' de one on de stick she didn't have no name.

The mule skinner sings it. All of what I have been saying is there.

IV. Dancing

AND now the arts: I approach them humbly and with disrespect. Humbly because I know the toil, the joys, the giving that have gone into them. All over the world from deepest Africa, Asia, even to industrio-puritanical America and loveless Europe, the arts have been practiced and still are practiced with simplicity and delight. Disrespectfully, because of all man's sorry exhibitions, his arts perhaps show him at his worst. Their fake profundities and little certitudes, their sophistries and snobbishness, their layered symbolisms reveal with deadly though unintended expressiveness the complicated little falsehood that is man. The arts in short are many and varied in their works.

I shall consider the arts as roughly of two sorts. The one sort includes the arts whose works involve action in themselves and continuous concrete readjustment in those who participate in them. The other sort are arts whose works are mainly perceptual and symbolic in content and require in those who participate in them perceptual discrimination more than overt action. I shall try to show later in the discussion of thinking activity that artistic or literary symbols in our so-called consciousness are themselves a kind

of action or substitute for action. The difference
thus between the action arts and the perception arts
may not be so drastic as it seems. Still there is a dif-
ference.

And I realize too that within the action arts, such
as dancing, there are continuous and integral activi-
ties of perception. In such an art, to act is to see. It
incorporates perception, most of it muscular, and
though I do not know just what perception means,
I am sure that in these arts it is not a separate process
imbedded in a realm called consciousness somewhere
above or beyond the overt action of the art. Aware-
ness the dancer has, to be sure, but his awareness is
part and parcel of the activity of dancing itself. For
dancing is not scholarship, nor is it objective, and
the dancer's perceptions, so far as they are artistic,
are inseparably involved in his dancing. They are
identified in the concrete situation.

This, to be sure, is characteristic of all the arts.
It is characteristic indeed of all consummatory ac-
tivity, as contrasted with purely practical activity.
For in practical life the perceptive aspect of the
situation is abstracted from the lean instrumental
activity and becomes more or less an external report
of progress toward the designated end. But the action
arts, such as dancing, are closer coupled, as between

action and consciousness, than practical activity, and closer even than the arts that are less active. Perception and action, in them, are identified. The dancer has not so much a consciousness of his dancing, his consciousness *is* his dancing. This I am sure, regardless of what the psychologist may say, is what the dancer himself will report. His dancing is his experience. He cannot and would not separate them.

The dancer is thus no longer a dancer, he is the dancing. He no longer is a so-called "individual" in whose "consciousness" is the perception of his activity called dancing. He is the activity—and this I think comes about as close as is possible to the great term "being." If it means anything, it means this direct identification of his individuality and his perceptions with his action. Or am I merely watching words rebound like tennis balls from the white wall of our helplessness? Words have their own resilience. But their bounce is erratic. If I criticize the philosophers and critics for not knowing where words will go, perhaps I should avoid such games myself.

It is precisely this escape from words that I think the dancer attains. He enters directly into the activity of his dancing. He escapes indirect symbols, verbal consciousness. He becomes dancing and finds there the primeval unity from which all thoughts,

all gods, all the objectifications of science, all the instrumentalities of practical life come. They too arise there. Artifices such as abstraction, definition and segregation bring them out to serve their respective purposes. But they are not art. The arts retain their concreteness and self-sufficing wholeness of function. They are organically complete.

But I should go on with the dance. It is the most intimate of arts. Because it is muscular, it lives within us more than any other. Its rhythm is the beat of life. The great muscles of the heart dance a life-long measure. The lungs dance, breathing; the belly dances, sometimes too much; the blood beats in the arteries. As an art the dance is a formulation of muscular activity that recapitulates the thrust and pumping of life. It is less a cerebrospinal than a visceral art. It lives just under the emotions and for them needs no translation.

For the same reason the dance is close to its medium and cannot but express it. For its medium is the human body. It comes from the body and expresses its character and beauty. The architect may build in wood but imitate marble. Or the classic Greek may build in marble but imitate wood. The painter, if he lack sensitiveness, may forget the necessary paintiness of the work that he produces and try

to paint in the characteristics of another medium. The photographer may try to capture the effects of paintings. The cook may imitate the Parthenon or a battleship. But the dancer must be true to the medium. His is a bodily art and dances always show it. There can be no detachment from his medium, or at least very little. He must express the muscular rhythms and contours of the body, if he dances at all.

No creature without muscles could conceive of the dance or even of rhythm as we know it. For the dance with its regular contraction and relaxation, its ordered ebb and flow, is muscular in character. Within these rhythmic patterns of activity movements may be varied, to be sure, for muscular rhythm is not necessarily the ticking of a clock or the invariable beat of a piston. The dance may have nuance and variegation, but its rhythmic movement and organism always is muscular. It is the most primitive of arts for this reason. It is a motor-rhythmic art, as Curt Sachs[1] says. Its symbolism, such as it has, is primeval gesture and bodily pose. It has an expressive form that savages, infants, even animals know in common with sophisticated men. Below the arts of the eye, of the ear, of the voice, lie the arts of the

[1] Curt Sachs, *World History of the Dance* (New York: W. W. Norton & Co., 1937).

bodily muscles, more primitively expressive than any.

The universe is the dance of a god, say the Hindus. Life is the dance of a man, says Havelock Ellis. The beat and movement of things is forever upon us. For the dance is not learned, the world enforces it. Man must dance. The compulsion on him is no less than on molecules dancing in a gaseous body. His dancing is the ebb and flow of his existence.

Sources of the Dance

Historically, the art of the dance has two great lines of tradition, the Egyptian personal, expressive dance, and the ballet group dance. The Egyptian dance is as old as man, or older. For thousands of years it developed in Egypt. It still lives there. Secondary centers, says Ellis,[2] were developed in Spain where Cadiz—as well as Egypt—became a point of export of dancing girls to Rome. Crete in ancient days carried on the Egyptian tradition, and from Crete the

[2] Havelock Ellis, *The Dance of Life* (Boston: Houghton Mifflin Co., 1923).

Greeks carried it much modified to Greece. In Greece it took new form, found new expression, became indeed the great Greek dance. It survives today in many patterns, from the art dance of Isadora Duncan to less deliberate forms. And behind it the tropic glow of the Egyptian dance shines from below the horizon. That deep land of death, as popularly supposed, still is dancing. For six thousand years the dance has gone on there without cessation.

The ballet originated in Italy as a feature of a marriage pageant in 1489. Beyond that, says Ellis, its germ lay in Roman pantomime and early Etruscan dramatic expression. The ballet is romantic in temper, as contrasted with the classic Greek and Egyptian modes, and retains much of its pageantry and pantomime. From Italy the ballet moved to France and thence in 1735 was brought to Russia. Here in the early twentieth century, under Fokine and Diaghilev, it reached its climax.

Contemporary dancing can conveniently be considered first as folk and popular dancing and, second, as an elaborated art form. The first of these, in my opinion, is by far the more important. It is less organized, more fluid, harder to describe and analyze, but belongs to the people. It is simply expression. It formulates people's lives. It is their life far more

than sophisticated art forms can ever be. For this reason the folk dance and the popular dance are really more artistic than the more symbolized, indirect intellectualized activities. They are more expressive in the direct sense, and if they lack the subtlety and discrimination of the "finer" arts of dancing, I would reply that life in its main stream is not subtle nor delicately discriminating. The identification with living rhythms and the re-creation of them, which seems to me the primary character of art, are found more surely in the folk or popular dance.

This kind of dancing can roughly be divided into ritual or tribal dancing, folk dancing proper, and popular or "ballroom" dancing. The first of these is found among primitive peoples as the rain dance, the corn dance, the snake dance, the war dance. All life is given dance form. Purposes, hopes, fears for the folk are danced out, not as a catharsis, not as an allegory, but in the belief that a mystical identity is created between the dance and the forces of nature. The dance, for the primitive person, is an integral and effective part of the operations of his world and of himself. The California rug weavers, whose hands move in a dance as they weave, give a charming example of the identity of art and overt action. The primitive world pulses with this dancing.

But in the modern world not much is left of ritual dancing except the sacred masses and forms in the churches. Here it is fixed and formal, but retains the primitive belief that ritualized action influences the course of nature. A deliberate mystery is accepted as the faith. And faith there must be, if this religious dance is to be significant. Though aesthetic, antiquarian and social reasons often are advanced for attending such rituals, they are at best beside the point and at worst hypocrisies. Faith remains, faith in this mysterious identification of the dance with universal forces, as the only way in which such rituals can retain their original significance.

By folk dancing proper I mean the simple dancing of traditional forms and tunes by regional groups of people. Folk dancing is usually group dancing and is done not for religious or tribal reasons but for the fun of it. It is a native rhythmic expression of the gaiety and action of life, and although love and sex have their unquestioned part in it they are diffused among other interests. The old square dances, the Virginia reel, the lancers and others are the dying remnant of group dancing in America. With increasing heterogeneity of population and of interest and with the rise of urban fashions, folk dancing by groups declined.

An odd revival, however, has occurred in recent

years with the "big apple." This and a few similar group dances became fashionable with a bang. Though probably they will not survive a brief notoriety, they may on the other hand indicate a radical change in modern popular dancing away from the pair dance and back to the group.

The Popular Pair Dance

The modern popular dance, or pair dance, as contrasted with the group dance, is traditionally a democratization and slow alteration of aristocratic ballroom dancing of a century and more ago. It carries with it much of the sex dalliance and smart romance that filled the lazy courts and drawing rooms of pre-revolutionary France. But it has a vitality, nevertheless, that makes it the most massive movement in the arts of modern times. Its strangely erotic posture, with male and female facing each other in fixed embrace, its sexual exclusiveness, with backs to all the world, its introverted romance have not prevented it from becoming a powerful and engaging instrument of folk expression. The modern "ballroom" dance is uniquely monogamous, or at least

was until the cut-in system became prevalent. In form and essential character it remains monogamous. It is a pairing in which there is no larger group interest. It is a romantic, if not erotic, concentration of two individuals on each other. This silent introversion of the "ballroom" dance is sometimes interrupted by more objective movements, breaking the hold, turning outward or even singing a group chorus. But this is rare. The dancers sweep round and round the great room, locked like Paolo and Francesca forever in each other's embrace, blown on helplessly by the winds of music.

No dance perhaps in man's history has this silent intensity of sexual individualism. It is a rhythmic ritual that has burned deeply into the modern soul. It is possibly the most characteristic artistic achievement of our monogamous institutions. But its intensiveness and the preoccupation in the dance partner are, nevertheless, broken through by more widely ranging forces. The pure gaiety and slam of much of the new dance music goes other places. The brash, unburdened temperament of American young people is also an uneasy captive in romantic forms. The modern dance indeed has gone places with a drive and tempestuousness that seemingly more "objective" arts have not achieved.

It is an amateur art. Like the folk dance it is dif-

ferent from the formal art of the dance and from most ritual dancing in having no professional performers. Other than a teacher here and there, the art of the popular dance is carried on by all who enter it. It is different also in the active participation of all who enter its precincts. The vicarious appreciation in modern sports, music, painting, drama, poetry is hardly known in the popular dance. This direct participation in the activities of the art by the millions gives it high status as art. It gives it also a unique character and quality that differentiates it from other arts.

Popular dancing has changed briskly in recent decades. It is closely correlated, of course, with the evolution of popular music. But the new dancing and music are not alone. In the ten years between 1905 and 1915 such diverse revolutions occurred as the new movement in poetry, the progressive movement in American politics, the early statements of Freudian psychology, of Einstein's physics and of pragmatic philosophy, the publication abroad of Frank Lloyd Wright's architectural work, the realistic movement in American prose, the fox trot, ragtime, the confirmation of post-impressionist painting. Nor are these various movements unrelated. They are in great part the repudiation of classical

absolutes and the envisioning of a new and human-
istic provisionalism. The conflict deepened, the
world strained tenser and tenser, and in 1914 broke
into war that is not yet over.

With it all the dance moved on. The formal
waltz and the two-step, themselves once radical, gave
way in public interest to a group of innovations led
by the fox trot, the tango, and the one-step. With
the development of these a different world of danc-
ing and a different attitude towards it came into
existence. German bands and systematic rhythms
gave way to negro nuance. Abrupt dynamics super-
seded shading and gradations. The off beat tapped
and thundered roughshod through the old measures
of the dance.

In general the dance became freer and more in-
dividual. The set pattern of the waltz and two-step
to which the dancer must adapt himself broke down
within these dances, on the one hand, and gave
way, on the other, to the free forms of other dances
in which innovation and the dancers' whim were
taken for granted. In the deep stream of the music
the dancers moved about much as they wished,
dancing the dance of themselves. It is, indeed, an
internal kind of stimulative music which moves men
and women to expression each in his own way,

rather than the compulsive music of external form. The great "ad libs," the swing men and Bix Beiderbeckes are not always behind a horn. Some of them are on the dance floor.

Because of its freedom and naturalness the new dancing attracted men as no dancing had perhaps since ritualistic Saturnalias or the tribal war dance. Where men in two-step days had been pulled by main force of feminine determination first to dancing school as boys then to formal dances as men, they now seized the bit in their teeth, as it were, and crowded the floors or stood in long lines as stags waiting to pounce. The new dance diffused through modern life. It entered the home informally. It became an adjunct of teas and dinners out. It broke into the afternoons. It extended itself to early mornings. It permeated all age groups, and dancers from sixteen to sixty commonly were on the floor together.

Dance crazes have swept across human society before. They flooded over Medieval Europe, they captured post-Periclean Greece. Even the early Christian movement was in some ways an esoteric dance, as the ancient ritual, the Hymn of Jesus, indicates. But modern dancing has a range and an explosive suddenness of development that is unique. It is secular but has a deep set, an almost pathological

expressiveness, that gives it a status beyond mere amusement.

In this sense modern popular dancing approaches Nietzsche's conception of the folk song as a Dionysian contrast to the more controlled and plastic art of Apollo. Periods rich in folk song, he suggests in *The Birth of Tragedy*, have been most violently stirred by orgiastic movements. Folk melody is generative. Folk strophe binds words into the music so that they lose their contact with the world of image and phenomenon, which is the province of Apollo, and enter Dionysian tune. Though we need not accept Nietzsche's reminiscence of Idealistic philosophy, his point is suggestive. The contrast is there. It applies less to folk song as such, at least such song as we find on the range, on the sea, in the southern mountains, and more to intense dance cultures like America's dancing now. But no one can deny the orgiastic frenzy of the modern jitterbug. This dance culture has arisen in America within the last thirty years and has spread thence to Europe. It is an authentic folk movement.

Though the phonograph and the radio, simpler clothes, personal deodorants, new band instruments, and the equality of the sexes all contributed to this great growth and diffusion of dancing, the change

in form of the dance itself and the change in music were the most significant. Dancing abandoned the European tradition. It went American.

Formal Dance

The formal dance as an art form is another thing. It is performed by professional dancers who dance that others may watch. With the exception of professional jiggers, tappers and cloggers, it is almost entirely an imported art, so far as America is concerned, that has taken little root here. The great ballet company or the Greek dance teams make pompous circuits across America. And the people go to see them. But few can tell what it is all about. Why should they? Their tradition lies elsewhere.

These formal dances are enjoyed for the most part through the visual sense of the spectator. Though he perceives indirectly something of the intimate kinesthetic rhythm of the dance itself he does not participate in it. An old man can watch a Pavlowa or a Fokine. A rheumatic granny can watch a Mordkin bound across the stage and have the same de-

gree and kind of perception of it, presumably, that young Mark Turbyfill, the dancer, has. Their perceptions are more or less standardized by the externalization of the art. There are, to be sure, exceptions, the Greek dance and the simpler movements of the ballet and the tap as taught to children in the schools and elsewhere can enter directly into the expressive rhythm of young lives. Taught in this way such dancing can grow up in the children's activities, it can change and develop with them. It is a gesture of living and becomes directly a part of that child's attitude towards the world about him But the art of the dance is not so often brought thus naturally and intimately into the growth of an individual. It more often conducts a costly, prestigious show for spectators whose own rhythmic experience has little in common with it.

The "art" dance is more than likely treated as an interpretation of some event or work of art. It is not an event in itself, but a representation of something else. It becomes thus a costume for events. And this is to be expected. When removed from the context of accustomed living activity an art must usually become abstract and as cleanly sterile as the numerals from one to ten, or it must borrow subject matter elsewhere and give it interpretative twists and deco-

rations. At this fork in the road classicism and romanticism take their separate ways. They both emerge from an already mature art, too mature, perhaps.

The art dance usually has chosen the latter and the stage is filled with danced dying swans, Chopin's nocturnes, tableaux, and well-chosen charm. Pretty girls are pretty girls, and most men like to look at them in action, no matter what they are dancing. But such crude valuations in the art dance—though not in floor shows—would never be accepted, openly.

This is unfair, however, to many of the more serious dancers. "Movement is lyrical and emotional expression, which can have nothing to do with words," says Isadora Duncan.[3] "Nor," she would no doubt add, "has it anything to do with the pictorial beauty of the dancer." As lyrical movement, dancing is less the interpretation of lyrics and emotions in some other event than the creation of them in its own activity. This is the artistic meaning of expression, it formulates the lyric validities of its own movement and thereby creates them. It is lyrical movement. And its value lies there in itself; it has no further sanction.

And as movement the dance comes close to the

[3] Isadora Duncan, *My Life* (New York: Boni & Liveright, 1927).

primeval reality of all art. It is near the sources. For its value is not to leave scattered over the earth in books or scores, in buildings or museums, created works of art. Works once created are beautiful, dead shells on the beaches. Living has gone from them. But the dance leaves no shells or fixed works. Its works are never created because it always is creating. Movement is the stuff of the dance. Lyrical movement, always fresh, always original, always creating its fluid, dynamic form, is the very substance of all art.

Other arts approach this source so far as they partake of the lyrical movement and dance or so far as they symbolize it. Music and poetry, the drama, the movie and oratory enter directly into the primeval dance. But architecture, sculpture, painting, all arts of space, and indeed space itself, are structurally also organizations of movement. They express movement harmonically. They capture for a moment its inner structure and reveal it, and in revealing it symbolize and reproduce it in another form in man's experience. They are chords of movement.

But the dance in its simplicity and directness and its melodic movement through life and with life is closer to us. It is life, or becomes it, in a way that other arts cannot attain. It is not in stone, or words

or tones, but in our muscles. It is a formulation of their movements.

The dance is four-dimensional art in that it moves concretely in both space and time. For the onlooker, it is an art largely of visual space combined with time. But for the dancer, and this is more important, the dance is more a muscular than a visual space rhythm, a muscular time, a muscular movement and balance. Dancing is not animated sculpture, it is kinesthetic.

Muscular Art

Other arts it is true are also deeply kinesthetic. Poetry, in my opinion, is as muscular in its rhythm as it is verbal or tonal, and expresses the musculature of the poet. Music is also muscular and only recently in the arts has been distinguished from the dance. And architecture lays down patterns of movement for those who live in buildings. It directs their left turnings and their right turnings, their comings and goings, their pauses and speeds in a great dance through all the days that they live there. It writes

thus a rhythmic score for the movements of men. They must follow it so long as they live in buildings.

This kinesthetic function of architecture is almost unrecognized by architects and others, although its significance in building as an art is, in my opinion, great. In a recent book written in collaboration with Frank Lloyd Wright I twice introduced the idea, but so far as I can see neither Mr. Wright nor any critic who read the book—good men all—had any notion what I was driving at, or even saw that I was driving. But the point is there, nevertheless. Architecture is treated too much as a picture. It is treated too much as an arrangement of spaces and volumes and materials, as something good to look at. I ask, now, what does it do in the rhythmic patterns of movement of a life? What does it do with the daylong dance of a man's activities? Does it give them new formulations and beauty? This is a subtle study which, except for a few questions of practical convenience, has never been made. Architecture is less frozen music than the frozen dance. Its halls and rooms and turnings are inevitably channels of man's movements. It has this unrecognized dynamic function. By means of it the architect could create the lyric movement of an unending dance in those who occupy his buildings.

But the dance, to return to the more directly muscular art, is not a guide to movement as in architecture, nor a profound symbolization and harmonization of movement as in painting and sculpture; it is movement itself. It burns and glows with life. Its forms find expression only as they enter living motion. It is fleeting, like life, but eternal in its passing.

This purely kinesthetic nature of the dance would not be well accepted, I am afraid, by either the ballet or the Greek schools of modern dancing. Isadora rather reneges in her fine statement that "Movement is lyrical and emotional expression, which can have nothing to do with words," and, evidently under the influence of current sentimental clichés and her readings in Kant, modifies her point of view. The dance now is less a bodily and muscular formulation of activity in its own right than an agency for intangible spiritual things (or words) beyond. The body, she says, "becomes transparent and is a medium for the mind and spirit."

As a working hypothesis such a point of view does give the movements of the body a kind of unworldly coherence and beauty. "I was seeking," says Isadora, "and finally discovered the central spring of all movement, the crater of motor power, the unity

from which all diversities of movements are born, the mirror of vision for the creation of the dance. . . ." And what is this center? She sought "the source of the spiritual expression to flow into the channels of the body filling it with vibrating light—the centrifugal force reflecting the spirit's vision. After many months, when I learned to concentrate all my force to this one Centre I found that thereafter when I listened to music the rays and vibrations of music streamed to this one fount of light within me—there they reflected themselves in Spiritual Vision not the brain's mirror, but the soul's, and from this vision I could express them in Dance . . ."

But the simple beauty and directness of action is not now in her words. It is obscured in the mists of romance. It is given sanction in remote and cloudy abstractions variously called soul, spirit, rays, vibrations, as no Greek ever would do. It has lost the concreteness and brilliance of movement as movement. It tends towards symbolism and ulterior sanctions. Had Isadora either remained American or become Greek rather than a Wagnerian European her theory might have been clearer.

Fortunately her dancing was better than her theory. In spite of her romanticizing, it was willfully

muscular and clean. It remained classic. In her training of children where rhythmic movements of the dance were bred into the growing life, her influence was beneficent and revolutionary. In the United States and Canada more than six million children are taking lessons in dancing of one kind or another.

The ballet, on the other hand, is more frankly muscular than the Duncan type of Greek dancing, but it too is all too interpretive and allegorical. It suffers furthermore from a stereotyped pedanticism of form, a rigidity of training and expression, that all the color of a Diaghilev or Bakst or the verve of a Stravinsky cannot overcome. The center of movement, according to this school, is the middle of the back at the base of the spine. From this point of rotation the trunk, the arms and legs must move. These trained patterns and systems of movements are more or less independent of the mind. The face is impassive, masklike. The personal emotion of the dancer, as distinguished from the emotion of the dance, is rejected, ruled out. Control is absolute. But the ballet should be a dance, not in color to the music of Chopin, but in white to the music of Bach, or, better, in the nude to no heard music at all. It should give up its French fashions of movements

and figures and seek the classic naturalism of the Greeks. Some of Isadora's techniques, indeed, might well be joined with some of the theory of the ballet to produce a new world dance of lyric movement in its own right.

But there are other great dancers and dances. The realistic movement in Europe, East Indian dancing, American dancers such as Ruth St. Denis, Martha Graham, or Berta Ochsner, all deserve attention that I cannot give. And why not, for that matter, include the thrilling Ginger Rogers and Fred Astaire? They I think are of first importance.

Perhaps the secret rain dance, or the corn dance, the snake dance of the aboriginal Southwest have more value than any of them. Perhaps the great dance teams of Polynesia that come hundreds of miles by canoe over the open water to dance at the midsummer festival in Tahiti are more important. I have seen them there driven by the beating of drums. It is a fierce and interwoven beat that makes the white man shiver and burn with the magic of it. But what it may do to white men is not important. The dance of the young men there living out their own rhythms is important.

V. Music

MUSIC is abstract dancing. Its origins are deep in the morning mists of man's long life on the earth. Its history and development are a story of the rhythmic and tonal aspect of his activities. In an earlier day music was embedded in the muscular action of the dance. As it was gradually segregated from the dance it carried these essentially muscular rhythms with it. Music is still and no doubt always must be nine-tenths muscular or kinesthetic in its perceptions.

This primitive rhythmic structure of music when actually embodied in the muscular action of the dance was highly complex. The simpler folk reach a climax and complication of rhythm that has been lost in great part in modern music and life. As Boas[1] points out, rhythms of this type do not follow the usual evolutionary course from the simple to the complex. They become simpler as man's history matures. I have listened to the beating drums of the Polynesians and watched their powerful, many stranded dancing without being able to analyze the interwoven patterns of the beat. A friend, Carl Beecher, a musician and composer who has found

[1] Franz Boas, *The Mind of Primitive Man* (New York: Macmillan Company, 1911).

in his mature experience about all that western music has to offer, tells me that Polynesian dance rhythms, intricate and exact as they are, have a subtlety that cannot be recorded in our musical notation. Modern music, in a word, has taken some muscular rhythm with it, in its emigration from the primitive dance, but not all.

For a dance to the beating of drums and the monotonous chant of voices can be rhythmically complex and varied. But the development of richer melody in the chant or the instruments and the later development of harmonic complexities of tone necessarily limit to some extent the free and subtle rhythms of a more primitive art. For rhythm is not necessarily measured. It is essentially the flow and succession of beats or stresses. It may be measured and regularly repetitive, or it may be unmeasured and rhapsodic.

As music matures tonal interests somewhat supersede the purely rhythmic beat of the dance. A differentiation within the dance can then take place. On the one hand it is a succession of movements, attitudes, poses, designs in space. This is analogous to dramatic ritual of which the older Greek ceremonies and dramas as well as the ritualistic movements of the modern church, sodalities, lodges,

fraternities are examples. On the other hand the dance is fluid motion in different tones. This is analogous to music.

Tonal definition in music came rather late in the history of the art. In western music it was not until the tenth century that accurate pitch and interval in tones displaced the nuances of plain song. And then it came because of the requirements of part singing. In modern music volume is still handled in nuances, while pitch is accurately measured. But variability in the pitch and quality of tone, whether it be primitive nuance or sophisticated measure, is in any case an elaboration and controlled variation of the rhythmic flow, which corresponds to the spatial elaboration and poses of the ritualistic dance. Melody, I suggest, is essentially a way to give figure and development to rhythm. It is a rhythmic form.

It might well be imagined that, in a different civilization and a different musical history, volume or loudness of sounds might be accurately distinguished. There might be measured scales of volumes built up much as we now build up scales in pitch. An "x" in volume would be half a degree less than an "x" sharp in volume. In such a system volumes would no doubt acquire a perceptual personality of their own as pitch now does. Nevertheless, volume

at basis would be a way of articulating and elaborating rhythm.

I do not propose any of this as an anthropological thesis. The origin of melody, a monodic order of different tones, may lie in other regions of music than rhythm. I do not know. The Greeks gave melodic form to their dramatic chants. Aeschylus developed dances for his dramas. Sophocles danced his works. Greek poetry and indeed Greek language with its pitch accent was melodic. But I suggest that melody—and later, harmony—are in essence rhythmical elaborations. They give body to rhythm, and variation. Where only a pause, a measure, an accent, a nuance in volume in the primitive monotones of the drums can articulate the beat, the color and the pitch of tones can add subtlety and vigor to the rhythms of more sophisticated music. Though tonal development somewhat limits the native complexity of rhythm, it also adds rhythmic values and subtleties.

Rhythmic and tonal melodies are appreciatively inseparable. They are conceived inseparably, enjoyed inseparably, and though a critic may find some satisfaction in pulling them apart, the musical value of such an operation is negative. Rhythm and tone are organically related in music, but the tonal aspect,

first as melody, later as a more elaborated structure of concomitant tones, called harmony, has been given more attention in historical times.

That rhythm is organically identified with tone is a point of view that, I must admit, is much at variance with the ideas of a critic and musician such as George Dyson.[2] Melody, he says, is variation in pitch that need not be dependent on measured time or dynamic rhythm. Such rhythm did not exist in serious music until the end of the sixteenth century. Before that music was of the voice, and the voice, he says, is not naturally rhythmic. Even less is it a metrical series of beats. The tyranny of the bar line came with the use of instruments. It was a necessary regimentation involved in the use of massed orchestras and choruses. With Bach, Mozart, Beethoven, music left song and turned to the dance. It was captured by a beat, a too regular pulsation.

Although music, Dyson says, has time as one of its dimensions, time in music, like space in painting, is not necessarily measured time, nor has it any natural beat or articulation that perforce is imposed on the character of music. In song, and particularly

[2] George Dyson, *The New Music* (London: Oxford University Press, 1924).

in sacred song, he says, is found the proper origin and character of music. From this medieval, relatively timeless, meditative, rhapsodic song, music emerges.

This ignores the equally proper origins that music may have in the folk dance, the folk song and ballad and above all in the rhythmic beating of the primitive dance. The capture of music by the rhythm of the dance, with the help of Bach, Mozart, Handel, Haydn, Beethoven, was from this point of view merely a movement towards the secularization and democratization of the art. But historical and anthropological arguments are not very effective. The question is whether music essentially is tonal or rhythmic. I cannot answer with confidence, but I suggest that tone is essentially a mode and elaboration of rhythm. The two, rhythmic pattern and tonal pattern, are at basis identical.

Though I would agree that rhythm, either in music or poetry, need not be metronomic, I would not admit that musical rhythm in general is relatively unimportant. Rhythm of some kind is always characteristic of muscular activity. It is characteristic, I think, even of the voice. There is pattern and beat in movement. This beating movement is structurally in all music. It is called time.

Music and Movement

Music, like dancing, is what I have called an action art. Though it is treated sometimes as a language of the emotions and becomes in the program music of a Berlioz or a Richard Strauss a deliberate symbolization either of personal sentiments or of external events, its value as a language is secondary. It finds its sanction for being, not in the symbolization of something other than itself, but in its own activity. In this there is emotional content, intrinsic beauty, or whatever it is that we may wish to name its value, but the value is inherent in the musical activity itself, not in the ability of music to translate or symbolize values found elsewhere in life or in the events of the world.

This in no sense is an argument in favor of art for art's sake. That I hope is clear. I refer to music as an activity, an activity that is immediate in value. And as an existing activity, not as a set of secondary relationships or symbolic interpretations, it is valued.

And music, I repeat, is not a language. Its sanction is not relational. Its burden of magic is not the interpretation of life or the symbolization of the individual, social, emotional problems that confront us. So far as it is music it is living movement. It is activity of unique value.

I wish that modern folk could forget their persistent efforts to justify everything always in terms of its relationships and instrumentalities in respect to other things. If this be the necessary nature of all justification, I then would ask, "Why justify everything?" That such functional and instrumental relationships exist among all events, activities, phenomena in our lives is no doubt true, but this does not require us always to evaluate them in terms of those discursive relationships. The very nature of consummatory value in our activities repudiates this point of view. In music as in other activities all through our lives we find value directly in the action itself.

This is mysticism, to be sure, but, like it or not, even the most sophisticated and confident modern critic will find it in his own experience. He may not know what it is. Quite possibly he will call it emotion, a word much used now-a-days to cover difficulties of that sort, but the non-relational aspect of value, the direct identification of his interest in the activity itself is there, and that is mysticism. For my part I would deny the musical validity of these outer relations which music may have to the other activities of life. It may express, and in much great music does express, the same deep realities and attitudes

that these other activities express, but it does not
refer to them in various musical cross references, as
the symbolists and programists assume. Music is not
lingual nor interpretive, and although a certain
coherence may be observed between Beethoven's
musical expression, let us say, and the tragic events
and upheaval of his life, it should not be assumed
that Beethoven's music is a symbolization of those
events and emotional problems. Far more correct
would be the statement that Beethoven's life sym-
bolized his music. His music was primary. It was
his sole expression. His life was a kind of obbligato
accompaniment. It took form around that central
certitude of music. Like all devoted lives, it had this
mystic focus.

Dance Hall Music

Music in modern times, like dancing, can be con-
veniently divided into folk or popular music and
music as a deliberate art. So far as popular music
is a modern creative movement it is chiefly an
American phenomenon. As a conscious art, on the
other hand, western music belongs in great part

to Europe—or what was Europe. The development of the two sorts of music is sharply divergent. Music as an art in the European tradition has attained a prestige and power and an elaboration of beauty, greater perhaps than any other of the arts. Popular music in America has the massive and spontaneous interest of the millions. Its velocity of production and circulation, or turnover, puts it, secularly, into the big business class. But music in Europe and America are in different times of day. For the one it is evening, for the other morning.

Popular music in America today is dance music. The two, dancing and music, have developed together and have been reciprocally influenced. Though songs come and go across a hundred million lips, they are songs in most cases that find their first authority and compulsion in a hundred million dancing feet. Many are not singable. Their prohibitive range and angularity are adapted to band instruments and to dancing. They are vocalized as a reminiscence of the dance or a nostalgic substitute. With the exception of a regional ballad now and then, a cowboy song, an Indian theme, a negro spiritual, they are love songs, sentimental, individual and above all banal, until danced. In dance music, not in song, the modern age is most at home.

This, to my mind, is nothing to regret. Though

music arising in the dance, rather than in song, will have its limitations, it will compensate for them in its energy and primitive fusion with action. If song as an art that depends in part on symbolization and word meanings has a wide range and variability of emotional content, the dance is more massive and direct. For the delicacy and varied colors of song are possible largely because the instrument is slender and delicate. It uses subtle substitutes and symbols for the presence of activity, and because the event itself, such as "Rolling down to Rio," is not there it is free to range at will among many emotions or factual experiences. But the dance is an event. It is massively there. Its range necessarily is less, but its power and artistic compulsion is greater.

Jazz music, as Deems Taylor[3] says, is limited in emotional range. It is dance music. And in spite of the jazz virtuosos and instrumentalists, who tend to take the music away from the dancers with their hot improvisations, I hope it will stay dance music. Its best values are there. When orchestras, such as Paul Whiteman's, still the dancers, and gather around them mere listeners who sit on their buttocks at café tables, or when a Duke Ellington has groups stand-

[3] Deems Taylor, *Of Men and Music* (New York: Simon & Schuster, 1937).

ing motionless, awed by ad libs, then the music, I think, has begun to lose its primitive power. It has become ear music. As such it is facile, free, of course, because the discipline and power of the muscles have gone from it. It has been transformed in part from direct activity to symbolic activity. The loss, I think, is greater than the gain.

Why should Benny Goodman be introduced in a "musical art" series such as are held at Ravinia on the north shore of Chicago? It was a sell-out performance, to be sure, that washed away the last of the series' deficit. But aside from that, it seems to me that Benny Goodman had no place there. And for this reason: The Ravinia audience is a fat sit-down audience, at least in the reserved seats, that listens obediently and acquisitively to week after week of proper, if somewhat remote, classics. What right have they to dancing jazz? Why build railroads to the top of Pikes Peak or Mount Washington? Why construct difficult automobile roads to their summits? The mountain tops should be reserved for those who can climb them. They belong to action, to the thrill of hard won air, to hardship. Opening them by railroad for all the unearned sentimentality of discursive *bourgeoisie* who could not climb a hill is demeaning. And jazz undanced at Ravinia presents the same situation.

Jazz should be a dancer's music. It is polyrhythmic, primitive. As Deems Taylor says, it is a kind of formula that cannot be expanded to universal scope. It is a beat, a thrust of movement that in my opinion should remain movement. The jazz cults, the jam sessions, the great band leaders whose every arrangement and idiom is known by their fans, radio jazz, record collections, are not the central value of jazz. Interesting as they are, it is the dance that counts. Removed from the dance into imaginative and symbolic elaborations it will eventually die. Nor can the incorporation of jazz movements in the works of composers of pretense, from Debussy's *Golliwogg's Cakewalk* to Milhaud's *La Création du Monde*, do more than add to it an extraneous prestige. Jazz belongs not in the concert hall. It can be there little more than a stuffed shirt of culture, a patronizing gesture to this, oh, so interesting world outside the genteel walls of the hall. It belongs where it originated, in the dance halls of the nation.

I could quite inconsistently suggest, however, that one of our great orchestras or opera companies might do well to forget some of its European tradition and its fear of impropriety, and import as an associate or co-conductor one of the band leaders of the day. Let it be a Paul Whiteman, perhaps, an Ellington or a

Goldkette, a man who could not be outfaced or abashed by his high company, a man who would not try to go high-hat. Let him whip the orchestra into shape. Let him teach it the new music, or bring in men able to learn. Let him make the orchestra American, not by denying the old, but by recognizing and producing the new. Let him encourage composition that would unify the savage power of this mass music with the intellectual tradition of the art.

But such a dream, I am afraid, falls apart from its own inner incongruity. I am asking the synthesis of divergent tendencies, irreconcilable movements. Their unification would seem to be impossible—at least until some great master does what seems impossible.

Historically this modern mass music has moved from the cakewalk to ragtime, marked chiefly by its syncopated time and ebullient, primitive gesture. Thence in the later war period it moved to jazz. This involved individual improvisation both on the part of the dancer and the musician in the course of the performance of the piece. Later, swing came in. Here textural quality and orchestral color were further emphasized. At this time, too, one of the most remarkable of musical phenomena became current, namely, group improvisation by the orchestra, lead-

ing off from different themes. This is called jamming
and is one of the most unusual examples of orchestral
technique in the history of music.

Swing, says Joe Mannone, is improvisation on a
predetermined series of chord sequences. It is in con-
sistent four-four rhythm with a slight emphasis on
each second and fourth beat. And "Wingy" Man-
none knows.

Where swing will go, no one knows. It has become
largely a matter of personal and orchestral virtuosity,
for which there can be little or no written record or
tradition. It is beyond notation. It varies with every
performance. It is literally indefinable, as the brave
effort of the first scholar of jazz, Hugues Panassié,[4]
shows. It cannot be fixated. The progress of swing
will thus be in the personal continuity of the tradi-
tion of orchestras and leaders. It is in other words a
regional movement. Its only life is its life now. It
would be better, perhaps, if all the arts were like this.
If they were less dependent on recording, embalm-
ing, and perpetuating their works for those who
neither produce them nor live in their milieu, art
perhaps would be more distributed, more decentral-
ized in its production, more native in expression,
less an imposition from above.

[4] Hugues Panassié, *Hot Jazz* (New York: Witmark & Sons, 1934).

Jazz has three types of producers, says Marion
Bauer.[5] The first are the song pluggers such as Irving
Berlin, the earlier George Gershwin, Zez Confrey,
Jerome Kern. Second are the great orchestrationists
whose instrumentations have become an American
type. Some of these are Paul Whiteman, Gershwin,
Ferde Grofé, Werner Janssen, R. R. Bennett. Third
are the intellectual composers of the traditional line
who have turned to jazz wholly or in part. Among
these are John Alden Carpenter, Aaron Copland,
Gruenberg, Deems Taylor, Raymond Thomas, De-
bussy, Stravinsky, Milhaud, Ravel, and even Hin-
demith.

There are also, I might add, the great improvisers
such as Louis Armstrong, Bix Beiderbecke, Jack
Teagarden, Benny Goodman, Frank Teschmaker,
Johnny Hodges, Duke Ellington and many, many
more. Only in phonograph records can their work
ever be repeated. And these no doubt are the most
important men of all in this movement.

But jazz and swing are not in great names nor
formal productions. The best work never is repeated.
Musical notation, written down in every lift and
nuance, is at best a slavish system, a paper slavery

[5] Marion Bauer, *Twentieth Century Music* (New York: G. P. Put-
nam's Sons, 1933).

that good musicians often circumvent. *Con brio,* now be fiery. *Calando,* now be softer and slower. *Religioso,* now be devout. Every note and instant is fixed, every breath and stroke determined. I would not abolish musical notation, to be sure, for I can see that in our heterogeneous world it is necessary, if the complex tradition and attainments of music be passed on. But I could wish that we were less dependent on the records. And I, for one, welcome movements such as swing in which improvisation, individual and mass improvisation, has a primary part.

When music is more a creating activity and less a mass of created works it will be better. Music then will enter the expressive life. It will be less often a sterile monument looked at from afar. I would not destroy all musical monuments any more than I would destroy the system of notation; they serve as guides, exemplars, stimulations in the expressive life. At least they should so serve. But they are incidental. We forget sometimes that the statues and memorials in the park are less important than the people walking casually among them. We forget that the stone and bronze are really for the lowly ones who look at them. And in the same way the great musical memorials are only incidents as compared with the musical

life and expression of the folk who wander among them.

From this point of view the fleeting character of swing and much modern mass music is a mark of its essential musical quality. Any young man with a horn becomes spontaneously expressive. Any dancer can become creative as he goes along. His created works to be sure melt away as fast as they are produced. But the creating is the more important. If the created works that crowd our culture could be quietly washed away shortly after their completion there might be more interest in the activity of art and less in the fixed creations. To jazz we should be grateful for its emphasis on the presentness and action of art.

Concert Hall Music

Music as a more deliberate art manifests itself in very different ways from jazz. Where jazz is hot, unconscious of itself, impulsive, the traditional art of music has moved towards greater sophistication and deliberate experiment. It has become an object of rational exploration and elaboration. Its technical

and structural possibilities are under examination much as a chain of carbohydrate molecules might be studied by the chemist. Some composers say that the musical possibilities of the diatonic scales have been exhausted. All has been said, they claim, in a language capable of no more discrimination than half notes, long cadences, bar line rhythms, and the approximations of the tempered scale. Modern music in this aspect is a clutter of experiments and carefully invented novelties.

And this is all to the good, but it is science, not art. If science relates essentially to the technical elaboration of how to do things where art involves the direct value of the doing, the exploratory movement of modern music is primarily scientific in temper. It is, of course, a necessary operation if the arts are to develop. It increases the range and scope of art. It develops new instruments and structures. It establishes new symbols and forms of expression. But the invention of a new chord or the discovery of a new scale is no more musical in itself than the invention of a new electric organ such as the Hammond. Nor has it any more effect on music. Much could be said in support of the thesis that the intellectual and structural development of music follows, rather than precedes, the development of musical instruments.

Both phases of music, whether intellectual in this sense or mechanical, are more on the scientific side than the artistic. Modern music, in a word, is first of all distinguished for its remarkable scientific development. It is laboratory music.

But this is not all. Modern music, headstrong, wayward, tragically confused as to what to say and how to say it, has mounted its horse, as the joke goes, and ridden off in all directions. If we require of an art that it be unified as a whole and expressed in a universal language known to all, if it must be a consistent symbolization of the era, then modern music is a disastrous failure. It has many voices, many symbolizations. It is known to one, unknown to another. But if an art may be as variable and polyvocal as the different individuals and emotional regions from which it comes in this heterogeneous modern world, then the diversity and contradiction of modern music may be acceptable. Modern poetry too has many different springs and varied characters. Modern art, modern cooking, modern architecture, modern costume, modern drama, also show the pluralism and centrifugal character of these times. Nor need these arts be expressed therefore in base eclecticism. They may be simply pluralistic in source and movement. Robert Frost, for example, is an authentic voice

of the age, but so also is Robinson Jeffers. The periods of art now exist contemporaneously, without compromise, where once they were successive.

In music the modern movement is roughly in two main directions. On the one hand there is a further turning back to the resources of folk and primitive music. On the other there is eager, almost feverish, extension into experimental forms and methods. Often both tendencies are found in the same work, as in Ravel's *Rapsodie Espagnol*, or in Bartók.

Although music throughout its history has turned naturally to folk song and dance for much of its material, this research into things past has not been a consistent exploration until modern times. Mozart used the songs of his vicinity. Bach turned to the dances of his time. They took familiar things and processed them, as the manufacturer of puffed wheat would no doubt say, and the result was—well— Mozart and Bach. But what was native folk lore to them becomes in modern times anthropological research. Beginning possibly with Liszt, composers set themselves to learn folk music. They extended their horizons and by research found music of value to them. At first this took a nationalistic turn. Chopin developed Polish music; Liszt, the Hungarian; Wagner, the German; Ravel, the Spanish; Smetana,

Dvořák, the Bohemian. Later music turned towards the primitive and the exotic.

The Russians, Borodin, César Cui, Balakirev, Rimsky-Korsakov, Moussorgsky, Glinka[6] turned to lore and legend, in which the exotic often gained precedence over the merely regional. Debussy sought remote themes, orchid notes in his garden. Negro melodies, Chinese, Indian, Turkish, primitives, regional idioms were collected and set, like exotic jewels, in the modern rhythmic and tonal structure. Though Debussy assimilated such things, others could not. This last acquisitiveness of a decadent romanticism ended in a music so muffled with borrowed finery that little native stuff was left.

A more wholesome folk interest, though with something of an antiquarian scent perhaps, was the resurrection of folk song and dancing. Old instruments were brought back, the recorder, the lute, the rebec, the harpsichord, the clavichord, the spinet. Old music was once more presented. Arnold Dolmetsch and his family in England are pioneers in the field of old instruments. David Dushkin in America brought back the association of building instruments and playing them. Music with him returned to the

[6] See Marion Bauer, *Twentieth Century Music* (New York: G. P. Putnam's Sons, 1933).

community. He erected, as it were, a musical Bauhaus. Alfred Kreymborg became a quaint, sophisticated troubador. F. J. Giesbert in Germany edited and introduced much of the old music. Hindemith composed for folk groups and amateurs. Folk song choruses, glee clubs, dance groups, have made the old songs almost popular once more. Cecil Sharp has revived old tunes in England, and John Jacob Niles in America. Carl Sandburg has brought out folk songs of America today. Singers from our southern mountains, and from the cotton country, the western plains, the seaboard, the northern forests have come with old songs and regional lore to make music in a modern world. Though it all adds to the interest and pride of a people, I for one am less concerned in the excavation of this material and the presentation of it to the good people of the Evanston Woman's Club than in knowing that the folk of the southern mountains still sing and that the plains and seaboard lore is still alive in the people to whom it belongs. If it can be brought out without corrupting and commercializing its essential value, however, it is welcome.

Musical Exploration

But modern music is an adventure in novelty. And the novelty of folk song is not enough; music turns to other fields for exploration. Some of this exploration is a sincere effort to expand the field and expressiveness of music. Some of it is fever, boredom, senescent substitute for power. Although Bach, Beethoven, Wagner, Strauss all were experimental, it is fairly true that their experiments were not for experimentation's sake. They tried new forms in order to express better what they had to say. Form was determined largely by the nature of their burden. Modern music, on the other hand, turns to new forms in the hope that technical exploration will discover something to say. The new structure may produce the burden. For music should not be considered a language saying something other than music. What it says is music and nothing but music. Moreover, the exploratory interest itself and the elaboration of new musical forms do indeed produce new musical realities. The new formulations of music are in this sense unquestionably creative. It is, nevertheless, more of a scientist's or technician's creativeness than that of a great artist. It elaborates new and interesting patterns, but it does not identify those patterns mystically with living value and reality. It is good

scientific creation, but it lacks the essential magic of great art.

This deliberate exploration began, let us say, with Debussy and Scriabin and moved on to a seeming climax in Schoenberg and his group today. In the large, this modern movement is away from tune and line and towards textural color and mass. It abandons the development of musical statement and turns towards qualitative enrichment and variation. It avoids generalized emotion, cosmic thrust, heroic joy and sorrow, and accepts only the slim, fiery threads of feeling relevant to each chord or structural synthesis or other internal relationship of the music. "Sound for sound's sake," said Stravinsky in his more recent era. And that is good. But sound may still be small or great for its own sake. It may be a code of minority, a technician's delight, or it may be liberative and revealing. It may be a realm of rhythm and tonal structure that has magnitude, depth, importance, beauty.

These explorative experiments are less in the field of rhythm or in the varied colors of instrumental music—which are more the impulsive developments of American jazz—than in basic scale changes, in the use of new intervals and in structural chord relationships. The conventional diatonic scale, well tem-

pered by Bach, has great limitations. Its compromises in pitch, its crude half-step intervals, its fixed tonal relationships prevent our music from having certain refinements that the numerous scales and delicate intervals made possible in the music of the Greeks and of most Oriental peoples. What we gained in the development of harmony we lost elsewhere.

This tonal poverty of western music is the point of attack by radical composers. That they can elaborate new scales, develop new chord systems, alter cadences is obvious. Whether they can establish these changes as new conventions is another matter. At present the multiplicity of the changes, including not only one new scale but numerous new scales, not only one new chord structure but several, not only untempered or uncompromised intervals but quarter tones, third tones, sixth tones, all this multifarious novelty makes it rather difficult to establish any change. The primary problem of the modernist is to give musical value as well as mathematical value to his tonal experiments.

For musical value involves an element of familiar identification and in that sense possession of the musical material. It has tradition. It has roots. Neither in art nor any other field is perception spontaneous. It requires a more or less gradual building

up of the perceptual configuration. It must digest its material. One of the greatest difficulties in modern music is simply indigestion. We need no doubt a Bach with some authority to make the critical changes that the new needs require and to reject the extraneous novelties that raise confusion.

What are those changes? I do not know. I suspect that the piano must first of all be repudiated as the dominating instrument. Quite likely it should be abandoned in favor of more flexible machines that can be adapted to a wider range of scales and intervals. It lacks sustained tone; it is incapable of accurate or variegated intonation. A new notation is also needed. Although rhythmic experiments, polyrhythms, or concurrent rhythms of different kinds, and multirhythms, or successively different rhythms, have had some attention in European music, rhythmic subtlety and feeling have not had a development corresponding to tonal development. So long as we use massed instruments in the form of great orchestras, massed voices, and in general treat music as a public event rather than a personal expression, rhythmic patterns will probably remain regimental and metrically coercive. Music for crowds, or, more politely, "audiences," will inevitably have the rhythmic character of a massed dance, or massed sound

with no rhythm at all. The jam sessions of some small American orchestras do escape these rhythmic and tonal regimentations, but they are rarely public.

Unfortunately rhythm and tone in modern music, or most of it, are treated as different entities, different problems. This I think is perhaps the main trouble with modern serious music. If tone were treated more as an aspect of rhythm, a variable in the rhythmic movement, instead of a mathematical and static pattern in itself, modern music in Europe might be more a going thing, a moving unity, a living organism, and less a series of analytic problems.

Music should also literally return to its senses. I mean by this the sensuous simplicity of rhythmic tones. Music is movement in which sensations of the muscles and the ear are directly involved. And this should never be forgotten. Rational elaborations, experimental progressions have their value. But whether it be classic, romantic, impressionist, post-impressionist, expressionist, neoclassic, neoromantic or otherwise labeled music, sense and movement, or sense in movement, are its primary realities.

Texture and Counterpoint

If contemporary music, as Dyson[7] says, is predomi-
nantly a development in texture, it follows that tonal
analysis and refinement, chord studies, rhythm ex-
periments and all the inner intricacies and aesthetic
effects of sounds in time will receive most attention.
Music, as it were, has abandoned evangelism to study
its own soul. It is analytical, introverted. Like an
adolescent who becomes aware of his own body, it
tests its strength and tries to increase it, measures its
height, studies this stride and that for running, and
in general is more interested in the facts and the
possibilities of its own mechanism than in other
things. It is narcissistic.

Modern textural development is mostly vertical.
It is a succession of chord colors, each one an organ-
ism of coextensive sounds, each one a wallop of in-
tricate sensation, but without much continuity with
each other. The melodic line is sacrificed. Horizontal
movement becomes less important. Massed sound
fills the moment like broth poured into a cup. Then
another cup is filled, and another. They become cu-
mulative, many cups filled with sound, but the simple
fluidity and movement of music through time is not

[7] George Dyson, *The New Music* (London: Oxford University Press,
1924).

there. Music becomes static in this sense: the significant relationships are those between contemporaneous events within the musical structure rather than between successive events. Harmonic development, which is characteristically an emphasis on sounds that cluster together within the boundaries of one common moment of tune, brings music almost to a full stop. Dyson goes so far as to say that tuneless music is preferable.

These two kinds of tonal relation, the simultaneous and the successive, though very different from each other, are, of course, tied closely together. In chord progressions and in melody, music has for many years practiced what Einstein only recently made articulate for physics, namely, that what is simultaneous from one point of view may be successive from another. A chord written vertically or horizontally is after all the same chord, although the successive phase sounds unlike its simultaneous phase. But in modern music the texturalists, or the party of simultaneity, are predominant.

Just what is the difference between musical simultaneity and musical succession? Though our ears can hear several sounds at the same time and thus perceive at once the totality of a chord and the constituent parts of it, this is by no means all of music.

For music, it would seem, is also involved in movement. It requires an order of sounds which logicians call asymmetrical and intransitive. The notes e, a, e, f, of the opening movement of a Bach concerto, for example, are in a dynamic order which cannot be reversed, abbreviated or otherwise changed. Each note has a lien, as it were, on notes to come. This is the nature of movement stated logically. Though I see no particular reason for being logical about it, such a statement does seem to reveal this identity of music and movement. Simultaneity in music, in spite of the tendencies of the texturalists, cannot replace succession, movement, rhythm.

With the decline of the contrapuntal method of Bach and his predecessors, piece work in musical execution became necessary. Counterpoint is the movement of parallel melodies through time. It is linear or horizontal in interest and development. Chords and massed color are incidental to the interweaving of the melodies. In such music each instrument, such as the violins as contrasted with the 'cellos, tends to carry through the performance one integral melody or part. Each instrument has distinction and interpretive importance. Its part has initiative and a certain artistic completeness. It is comprehensible to the performer and has a function relatively independent in the cooperative whole.

But modern textural music, chord systems, vertical explosions of sound have changed all that. The orchestra now performs for a massed and objective public, or at best for a virtuoso conductor. The parts are fragmentary and broken. They have their place in the intricate and massive whole, to be sure, but no musician, playing his instrument in the orchestra, can have any notion of that whole or of any artistic completeness. It is merely a blurt here, a roll and a run there, a fragment of theme, if there be any theme, an endless *pizzicato* on one string.

The musician is reduced to piece work. What has happened to the industrial worker everywhere in the modern world has happened to him. His work becomes a fragmentary bit in a whole organized far beyond his perceptual scope. It is beyond the range of life, and always will be. What the value of this may be to the two-dollar-a-seat audience I shall not try to say, but to the musician it is a reduction from art to craft. There is little doubt in my mind that this type of modern music is involved in the modern tendency to perform for money before large audiences rather than to play for the interest of playing. It is a function, unconscious of course, of the artistic vicariousness of modern times and the segregation of consummatory values in specialized activities remote from daily life.

In modern music, to be sure, there is some resistance to this tendency. Hindemith and some of the younger composers, such as David Van Vactor, are moving towards Bach. Time and horizontal pattern, counterpoint and urgent rhythm mark their work. Stravinsky has turned in this direction. Prokofieff destroyed his manuscripts written in complex color and texture in order to clear the way for his reaction.

The development of amateur orchestras and bands, already well begun, can be of incalculable influence on the course of music. And most of that influence, I think, will be good. The jam sessions of modern swing orchestras, with their series of solo improvisations by members of the group, are also a wholesome revolt against the musical fragmentation of much pretentious work. They too are acting as amateurs in such free-for-alls.

The amateur player in an orchestra need not accept the subordination, the indistinction and general boredom that much modern music imposes on the professional. He will demand parts that are fun to play, that have significance in themselves. He will demand music interesting from the performer's point of view. This alone is a revolutionary principle in modern art. Its effect, I think, would be wholesome for art and for human beings as well.

I dare not predict that the growth of amateur orchestras will bring back contrapuntal music, but such a thing is not impossible. It is not entirely an accident that small, informal orchestral groups are turning to the violin, the flute, the recorder, the 'cello and other flexible instruments. Nor is it an accident that they are playing newly edited but ancient suites, sonatas, preludes, by composers such as Purcell, Eccles, Bach, Schickhardt, Mattheson, Chédeville, Croft, Finger, King, Weldon, and many another rarely heard in these chordal days. They are played because part playing in them has an integrity and line that cannot easily be found in modern composition.

The New Scales

But not all movements in modern music nor all modern music should be rejected. Although its experimental expansion has probably passed our power to assimilate, there is much that is new that will be, if it is not now, musically good. Neither the new subdivision of tones into quarter, third, sixth, two-

third intervals nor the whole-tone scale, says Dyson, is destined to be important musically. Even Busoni's division of the present whole tone into sixths, giving a sixth, a third, a half step within the scope of the present half tone, is rejected as being beyond the scope of our musical language. And the whole-tone scale, consisting of six tones, each of which is one whole tone from its neighbor, and of six more tones in the same order but starting one-half tone higher than the other set of six, is threadbare already, says Dyson. It lacks the variability necessary to development, and, unless something significant is worked out from the dissonances derived by crossing one set of six with the other, the whole-tone scale will not be important. But this is the opinion of a critic whose high distinction is rather on the conservative side. The whole-tone scale may have more life than he thinks. The use of narrower intervals of tone, such as those suggested by Busoni, is well within possibility.

Still another system of tonality is the twelve-tone scale. This, very likely, contains more of the future of music than most other modern experiments. It is based on the relationship of tones called chromatic. Instead of seven whole tones plus five half tones, found in the diatonic scale, the twelve-tone scale

comprises all the so-called whole tones and half tones in the octave without distinction. The result is twelve tones of equal value and relationship on each of which both major and minor triads may be based. The result is sometimes called atonal music. Schoenberg, once of Austria, later of Los Angeles, has made this his difficult and highly intellectualized province.

But set intervals between tones, in spite of their partial confirmation by the science of sound, are after all artificial. Eventually, in a perfect musical system, such jumps from tone to tone will be no doubt removed from the scale—or what corresponds to the scale. The structural base will be a continuous *glissando* with no fixed interval greater than one vibration in scope. It will bear a strange unearthly fruit, I am sure, quite beyond my own somewhat primitive musical sense, but that is where chromaticism, if continued, must go.

Musical Philosophies

In temper and philosophy modern music has moved down a course similar in many ways to the course

not only of the other arts, but of science, religion, morals, philosophy. Some of this similarity comes from direct contact between composers and men of art and intellect. Debussy's friendship for the impressionist painters Manet, Monet, Renoir and others was a direct influence on his music. But more of the similarity of the courses of the arts is a natural convergence in their development.

If Richard Strauss was the last of the traditionalists in music, radical as he is in many ways, Claude Debussy may be considered the first of the moderns. Technically he is classified among the impressionists, although his music often has more of a romantic, even sentimental, softness, than does the painting of his theoretically austere fellow revolutionists, the impressionists—Monet, Manet and others. Impressionism in painting is as nearly scientific in attitude as an art well can be. It led the way in modern times in abandoning representation and "pictorial" quality. It turned to the analysis of light, and on the theory that, after all, light is all that any one can see, it set out to paint the skin of light, and that only, which covers all things. Anatomy and structure were ignored but light was analyzed, painted in dabs of different colored paint. These dabs were synthesized by the spectator into the color desired by the artist.

It was the painting of surface, not what is known, but what is seen, and impressionism for that reason is an accurate term.

Musical impressionism according to such a theory would be a music of sound, and sound only. No inference as to structure or formal pattern would be relevant, nor would dynamic emphasis and emotional expression be permissible. Such music would be formless and without dynamic contrasts. It would express nothing except the quality and beauty of perceptual sound. What place rhythm would have in purely impressionistic music I am not prepared to answer. Sound as such is one thing, sound in time is another. Whether or not "sound as such," without time, is perceptually possible, the impressionist presumably would consider sound in time the basic stratum of music. But form, structure, scales, perceptual conventions and habits, inferences, expectations, so far as they are not sound in the hearing would be ruled out. Such impressionism would need, moreover, to include an analysis of sound as a sensation and to develop a technique for presenting it freshly. Chord analysis, the study of the components of a single tone, or possibly some new approach not now used, might be the direction that impressionism technically would take. The result in any case would

be a music in which sound is taken to pieces and reassembled in a new, fresh and interesting way. It would be rich in new tone color and texture. Perhaps also it would be a new revelation of time.

Against such hypothetical music Debussy's work is only in part impressionistic. New tone color he has indeed. His music is predominantly a delicately arranged assemblage of pure sounds. Sound quality is, I think, its main interest. On the other hand Debussy's work is romantic in temper, exotic rather than scientific, and the "impressionism" of it is fully as much a perceptual impressionism of sentiment, brief, casual, cursory, with ten-second emotions, as it is the analysis and presentation of sound for itself. Debussy was in contact with the impressionist painters of France, but his music, though impressionistic, is not the consistent empiricism that became known as the first scientific effort to approach painting. He was influenced, of course, by many others than the painters. The poets Mallarmé, Verlaine, Laforgue, symbolists, whose work though exquisite had hardly vitality enough for fresh enjoyment of sound or anything else for itself, were also influential on Debussy.

As post-impressionism in painting followed im-

pressionism with an almost revolutionary reversal of values, so in music a movement toward inner form and significance, a kind of mystic integrity, succeeded in some modern music the lovely surface music of Debussy. Scriabin, were he less involved in romantic and philosophically confused theories relating to theosophy, could probably be considered post-impressionist. Stravinsky in his period preceding primitivism and neoclassicism was post-impressionist.

Where impressionism in painting devoted itself to an analysis of surface, post-impressionism sought through intuition the form, structure and design of being. Whether it be Cézanne or Grant Wood there is a penetrative movement and the seizure of the essential or formal integrity of the object. Post-impressionism is intuitive, even mystical, in its approach to reality. Such an intuitive penetration is characteristic of Stravinsky. This variegated genius does not always recognize it or give it main emphasis in his music, but he is probably nearer post-impressionism in painting to Gauguin, for example, than any other musician. Sibelius in temper is not alien to the post-impressionists, though, so far as I know, he is unaware of the schools or movements of musical

fashion. Rather above the battle, he goes his northern way, but his temper is penetrative, formulative, rather than impressionistic.

Expressionism in painting is closely related to post-impressionism. It has been called, indeed, the German variant of post-impressionism and is similar to it in its mysticism and penetration but differs, presumably, in being less metaphysical and more psychological. It is devoted more to the expression of reality, particularly to the expression of the emotional counterpart of any real thing, than to the discovery and formulation of significant design. In music Arnold Schoenberg has been called the outstanding expressionist in this special sense. Though I must admit that I am doubtful whether different arts can be theorized in definite parallels in this way, it is clear that they converge at least in general attitude and vision.

In his search for inner beauty, says Marion Bauer, and in his effort to expand the possibility of the musical expression of it, Schoenberg evolved the atonal (or chromatic) style. A type of music follows that to the unsophisticated ear seems as alien a language, as wild a gibberish, as any convention of starlings in a tree. The melody is discontinuous, dissonance in unholy associations displaces the accus-

tomed consonance, phrases are broken, the sonata form is abandoned. But to the experienced ear it has meaning. In Schoenberg and many another modern, indeed, the musical situation approaches the condition of mathematics on the introduction of non-Euclidian geometries. Granted the postulates, anything can be made music. Music in other words finds itself forsaking law or what was thought to be law, and establishing itself only on convention—and not much of that. Schoenberg himself believes that dissonance and its "harmonies" will in time be intelligible to musical audiences. That time, however, has not yet arrived.

If Schoenberg's work in temper, though not in obvious form, approaches neoclassicism, the work of Paul Hindemith goes even further in a classical direction. This does not involve, of course, a return to the familiar lucidities of Bach; it does mean, however, objectivity of attitude and a development of the formal aspects of music. For the moment at least, European music is classical in temper. It can remain so for many years, for there is a world of new music, new relationships, new scales, harmonies, forms, patterns, to explore and to confirm. Years could be spent in consolidating the changes and movements of recent times. Whether this will be done no one knows.

Europe still is feverish, neurotic, broken and disorganized. It is more likely still to seek restless novelty than to settle down. As for America, we have our own way to go. We are on the march. Ten million folks are studying music here. Of school bands and orchestras there are 156,000 in the United States.[8] It is a massive march. I hope we shall stay at it.

[8] *Life* Magazine, December 12, 1938.

VI. Cooking

Two of the arts of action are dancing and music. But the world is full of others. Were it possible to give this book a balance corresponding to their actual significance in our lives, volumes, or at least chapters, on these less organized arts of action should follow. But this I cannot do under the conditions that time, space, knowledge, and the exigencies of book form impose. I can take them up only as incidents. These less conventional arts of action such as rhythm in work, the arts of humor and romping, the arts of conversation and convivial association, the arts of "polite" activities, of love, of athletics, games and the basic delights in activity itself deserve more attention than they ever get in written books. They are diffused throughout our life, and if their criticism and symbolic formulation are left to so diverse a medley as scientific management experts, sports writers, etiquetteers, pornographers, and the Izaak Walton league, they are no less important. For these diffused arts also have their forms, and if they are not as highly articulated as music and the dance, they are perhaps more universal. They too are a dance. But I must turn from these, though with some sense of guilt, to the more conscious arts found in definite systems of symbolization.

And there are other arts of action, humble but important. Cooking, or food preparation, including the consumption of its product, is an art of action. It is subtle and pervasive. Its ateliers are found wherever man and woman live. Why should this homely art evoke only sniffs from the critic—and most other people too? Why should the millions who practice this art every day so often consider it demeaning. Epictetus was a slave in Rome. Haydn, Mozart wore the livery of servants in great houses. Perhaps our best artists today are the housewives and their servants in the kitchen.

If music is an art founded on a basis of physics and physiology, cooking I suppose is an art founded on chemistry and also physiology. It is a plastic art in the primitive sense of the word and though the principles of taste in food and drink seem less suited to elaboration and mathematical statement than those of hearing or vision, they have their melodies, I am sure, as well as some suggestions of counterpoint, and even chords and harmonic structures. The cook, in other words, has the problem in her art of both simultaneous and successive combinations. It is an art primarily of textural effects and taste color. The rhythmic factor seems to be subordinate. Or at any rate, as Dyson would say, it is a rhapsodic rather than a measured rhythm.

Although modern cooking has retained its folk character more than most of the formal arts, it too has moved toward cosmopolitanism in recent decades. Once the art had a regional flavor, but with the new world came new cooking. This change was revolutionary both in the subject matter of cooking and in style and technique. Like a bear, man ate meat in the older days when he got it, and then in huge quantity, but between times he subsisted largely on cereals, vegetables, and what local fruit and milk were available. His foods were local in origin. Through the winter, on the march, or on shipboard, cereals with some salt meat were eaten. His food and the art of cooking were a seasonal affair, and seasoned, and had that type of astronomical rhythm. But with commercial farming, industrial production, better transportation, refrigeration, this was changed. The range of the diet increased, the curve of eating evened out, food became variegated, cooking became pluralistic. Not all people are well fed in the western world, far from it. But the oscillations are less. Meat, fruits, vegetables, milk get around more, across the seasons, across the lines between city and country.

And the art of cooking has had its corresponding eras. From a kind of greasy classic style founded in old England, a cooking focused on the unadorned essentials, such as meat, bread and potatoes, the art

migrated to America where it divided into two streams. The southern style was focused mainly on corn and chicken. The New England style turned towards beef, pastries, and, in its western variant, milk. These, with certain minor influences and arabesques coming from the Mexicans of the Southwest, from the fish cultures of Massachusetts, from the Creoles, from the negro love of pork, constituted what may be called roughly the classic age of cooking. It was regional in character, but had, nevertheless, an objectivity, an austere design, and a simplicity that was classical in temper.

The romantic movement in cooking came mainly from France, through the great cities and through the menu cards printed in most exclusive and fashionable French. These menu cards look like poems by Ezra Pound—an admirable artist—and the average American reads them with about the same accent and enlightenment. The dissonance of acids, and incongruous salad mixtures came in. Exoticism was rampant on the dining table. Strange foods and stranger combinations designed for thrill appeared.

Impressionistic cooking, delicate bits and whiffs floated in. Every restaurant had its Debussy. Program cooking, mock duck, mock turtle soup, salads that looked like flowers, butter pats that looked, not like

butter, but like sea shells, mashed potato metaphors of garlands, funeral wreaths, jellies that imitated fish, alphabet crackers, cigarettes flavored with vanilla, desserts costumed in Louis XIV parfait came in. Every kitchen had its Richard Strauss, every sideboard its Berlioz. And the symbolists also were there, in the kitchen sink. I have seen in a dressed up radish the melancholy perfections of the *fin de siècle* and in snobbish salads the confident exoticisms of T. S. Eliot. Chinese, Hungarian, Provençal, Spanish, German, Russian, Swedish, Turkish, Dutch, all had their fingers in the new pie. Period cooking, like period furniture, added a bit. Fancy foods, odd sauces, intricate visual designs in food, and a great wave of table gentility submerged the land.

More recently a movement, which may be termed neoclassic cooking, has gained strength. Science has been summoned and the functional values of the art considered. Chemistry, calories and withal a good deal of common sense characterize this school. It is classically objective, cool. It returns to fundamentals. Vitamins and minerals gain recognition. In jewel clean kitchens, shining with electrical machines, mixers, thermostatic ovens, chromium-trimmed sinks, this is the American style. Such cooking lacks perhaps some of the piquancy and verve of the French

or the passionate massiveness of the Russian or Swedish, but it is streamlined. It is as sound and tempered, and as wholesome, as a prelude by Bach. In the art of the dance of Isadora Duncan, in architecture, in machine design, and in cooking America has become the modern representative of the classic temper.

VII. Poetry

FROM cooking to poetry is not so great a step as it may seem. For poetry, and to some extent literature in general, is an art of action. It is customary I think to judge the value and distinction of an art by the scope of its symbols. This may be an unconscious judgment but it is made no less. Because cooking is symbolic in only minor and accidental ways and is limited in scope to that which can be directly tasted, smelled or sensed in some way without much of any conceptual accompaniment, we are likely to think it a low art, if art at all. While symbolization, or indirect experience, in the dance is somewhat more developed, the dance from the conceptual point of view still is rather primitive. In music the range of symbolization is much greater, though in fields beyond the strict values of music itself it still is limited largely to the symbolic expression of the emotions. In poetry and the drama, however, the symbolic range includes just about all the fields of human interest and experience. Though I, for my part, am doubtful whether arts should be judged by their range of indirect experience and their conceptual content, beyond their own immediate activities, these differences in the arts must be recognized. I shall take

up more definitely the question of symbolization when I discuss the thinking type of activity, for to this type of activity the symbolic arts in part belong. For the present it is enough to admit that poetry is partly thinking.

But I would not like to believe that poetry is all thinking. Primarily it is an art of overt action, it seems to me, and like the dance and music, is based on physical rhythms, muscular movements and muscular or kinesthetic sensations.[1] I would suggest further that just as tone differences may be ways to give variegation and pattern to the rhythm of music, so the use of words and word meanings in poetry may be ways to organize and make articulate the rhythm of poetry. An art I think is activity formulated and valued for itself. Its elaboration and enrichment by tones or words can not carry it much beyond that primary reality.

Words, after all, whether in poetry or out of it, are substitutes for action. They are substitutes for action or for things that relate to action; they are short cuts in the economy of human experience that give us a range and command that no other animal can attain. It is thus not so extreme as it may seem to say that

[1] See Baker Brownell, "Kinaesthetic Verse," *Poetry, A Magazine of Verse.* April, 1923.

words in poetry are in great part elaborations of the rhythms of action. Though the point of view may not be an easy one to take, it must be taken sooner or later either in poetry, the arts, in psychology and philosophy or elsewhere if the old dichotomy between thought and action that has broken western culture is to be done away with. Words, thoughts, yes, consciousness are essentially elaborations of action. And by action I mean overt, muscular, living activity.

I come thus to a thesis on poetry that to many will seem crude in the extreme. How can these delicate formulations of sound and meanings, these fiery penetrations into being, ever be identified with action? And to make it worse, the action is presumably muscular. My only answer, a hesitating one, is, first, that action is alien to the realm of values only to those who make it so. And, second, "meaning," which these critics tend to apotheosize, is after all a function of activity. Our world is a system of activities of which meanings are delicate elaborations. They are the outcome of a symbolization process which is itself a kind of activity. Activities telescope themselves, they form clusters, they have trends, implications of more action, conflicts which for reasons of economy are given primary, secondary, tertiary, or even more

remote symbols. They are, in short, given words. The realm of meanings rests on this symbolizing activity. Meanings and the consciousness of them, the verbal articulation of them, all are distillates of action. They are condensations, or compressions, of action.

That such a thesis goes deep into the primary problem of our western dualism, the fatal cleavage between thought and action, I am well aware. And I do not presume to have so briefly solved the problem as this suggestion about poetry may intimate. But the answer does lie in giving the proper status to the activity of symbolization and in the analysis of symbols, words, meanings. Meanings, in short, have no status in themselves, but only as they are references[1a] to action or patterns of action.

From this point of view I may not be so far wrong in saying that poetry is action, not only in its rhythmic movement, in its emotions, which are attitudes towards action or qualities of it, in its intonations, but indirectly in its symbolization and use of word meanings. A cheque on the Northern Trust Bank, for example, has no status of its own but only as a symbol of the activity of the bank and of the depositor in paying it. Words too are more or less indirect

[1a] See Ogden and Richards, *The Meaning of Meaning* (Harcourt, Brace and Company).

cheques on activity, and though we pass them around
fluently enough in poetry, prose, or conversation, or
in fiction become parasites through them on activi-
ties which we ourselves never perform, this is their
eventual significance. A noun, such as sun, equally
with a verb, such as lift, has a function and reality
for us only so far as it is a point of reference and at-
tention in the web of our activities. It is intelligible,
indeed, so far as it is related through activity with
the organic, moving complex of our world. Poetry
too belongs in this world web.[2]

The range and remoteness of this symbolization
is by many people used as the criterion of an art
compared with other arts. But of this, as I have said,
I am doubtful, unless, perhaps, the value of the art
be in inverse ratio to its symbolization. The amount
of symbolization or the use of conventional signs is
more likely irrelevant. If art is an activity valued in
itself and formulated to express that value, the rest
that it may carry is comparatively unimportant.

[2] See Ananda K. Coomaraswamy, "The Use of Art," *American Re-
view,* January, 1937.

The Two Poetries

But poetry does not reside in these explorative and uncertain explanations. It avoids exegesis, as a girl at a dance sometimes avoids the chaperon, and that no doubt is part of its magic and beauty. Modern poetry, particularly in America, is rich and many voiced. It has broken through the crusts of literary and social convention with power and the fluttering of many wings. In twenty-five years it has established not one but many movements. Any one of them would be enough to give a time and a people pride. Together they are easily our greatest era in the art of poetry and one of the distinguished eras in all western literature. Perhaps that is big talk, and in any case it is not very important so far as the content and beauty of poetry is concerned, but it is true.

In these poetries of the modern world two main lines of movement can roughly be distinguished. One goes back to Whitman. It is regional, naturalistic, mystical, for in poetry these terms can be joined, and is less concerned in its new methods, techniques and forms than in its content. The other line goes back through the French symbolists to Poe. It is romantic, introvertive, aesthetic with a central, compulsive theory or method which makes of it a defined school. This school is called symbolist. A poet may

belong to the Whitman tradition, or partly belong
to it, quite unconsciously. He may never have heard
of Whitman. But a poet is hardly a symbolist, or in
any way associated with symbolism, without some
knowledge of the theory and a sophisticated acquaint-
ance with its attitudes. Lindsay, Sandburg, Masters,
Frost, Jeffers, Millay, Robinson, Engle, and even
Tagore, Ridge, Cummings, MacLeish in his later
work, and possibly Wallace Stevens belong more or
less in the first line of tradition. Eliot, Pound, Aiken,
Crane, Yeats, Auden, Spender, Lewis belong in the
second line. There is also a group of persons who
spent their youth cultivating Paris and the symbolist
movement, then suddenly went proletarian with
Moscow as their center when the new thing came
along. It was a sudden change for them from tenor to
bass. If it were poetically authentic, it would place
them now in the Whitman tradition. But poets don't
jump ship in this way and retain their integrity. A
man can change his mind, never his poetry. Most
of this group are more articulate in criticism, where
they pluck a bitter string for revolution of one kind
or another.

Not all proletarian or revolutionary poetry today
is written, however, by weak men seeking distinc-
tion in a great cause. Nor is it all by young men of

poetic fashion in New York or Paris turning to the latest exoticism. Though a host of symbolist poets and others have sought the thrill of "seriousness" in so diverse causes as royalism, Catholicism, Marxism, occultism, proletarianism, fascism and what not, there are others who belong to the words they say. The work of Lola Ridge, the words of Bartolomeo Vanzetti before his execution, the invectives of Granville Hicks, the poems of Carl Sandburg, of Archibald MacLeish, and many another, come from no little snobs. They are persons of size speaking.

I should distinguish, perhaps, between proletarian or revolutionary poetry and so-called propaganda poetry. I rather dislike to try, because the puddle of this particular question is roiled and dirty and swarms of partisans assail with sting and stink anyone who comes near. A part of that swarm is composed of former symbolists who have shed their iridescence and become, my God, how tough. Another part is composed of former churchmen of certain types who find that their accustomed techniques, evangelistic on the one hand, repressive of opposition on the other, can flourish vastly in the new soil. Another part is made up of youngsters and some not so young, characteristic products of a defective educational system, who have never learned to value their

liberties, to feel responsible for their continuation, or to foresee the misery and terror that come with the loss of them. And another part, perhaps the largest, is composed of people who have suffered or have watched other people suffer under the massive wheels of an industrial and financial system which no one can stop, until it bogs down of itself in the blood and flesh of its victims. These people are not thinking about this or that theory of art. In their emergency they use what weapon they have, often only a poem, for their defense.

Such folk have "been there." And I doubt whether they generalize their use of the poem into the doctrine that all art is propaganda, or assert the rational necessity of events moving in one way or the other. They have been close to real things; they have felt the change and carelessness and inconsistency of them, and as long as they keep that contact they are not likely to try to regiment all phenomena and attitudes into one rational pattern. Their ideology is not naturally Marxian. For if Marx had been a workingman instead of a bourgeois bookworm—at least many of his followers would so name such a person today—if he had earned his living instead of getting it from Engels, these pedantic absolutes of ideology might not now be obstructing an intelligent attack on the

problem. If Marx, in other words, had thought more with his muscles and less with his head, if he had been more a part of the rhythmic, variegated, flexible world of muscular and physical events and less a part of the abstract, easily consistent, symbolic world of thought, he would have been closer both to art and to the workingman. His thinking was rabbinical in quality, not proletarian.

The point is that art, whether it be poetry, music, painting or the dance, is not necessarily focused on the social problem, or the individual problem, or the sex problem, or any other particular problem. Art is human activity and as such will have human content. It may be the social problem; it may be religion; it may be nature and man's naïve surprise and joy in it; it may be almost anything humanly significant. But it will not be art for that reason alone. It will be art so far as those activities are given form and consummatory value.

But I am wading into certain trouble. If Marxian scholars should read this, I am sure they will shout gleefully, "Obviously, he doesn't know much about Marx. For does not Marx repudiate ideas as a way of influencing behavior?" And before I reveal further whether I know or not, I shall leave Marx, for, after all, he is not very relevant to questions of art.

I shall try to return once more to poetry. It is a long jump.

My answer to the question is that propaganda cannot get into art if it tries. The accepted meaning of the word propaganda, I think, is the use of instruments of some sort to promote by persuasion an ulterior end. I grant that poetry may be used deliberately to promote some end or it may be naturally functional in an area of life larger than itself. It may be used, as Milton used it, to promote the glory of God, or it may assist the circulation of the blood of those who read it, or promote good humor, act as a catharsis for the bowels or the emotions, or otherwise assist the living process. It may be naturally functional or be used deliberately as propaganda, or both. Most activities in the natural world, if not all, have both practical and consummatory values. But poetry itself is not propaganda for the glory of God nor a catharsis for the bowels.

A sapphire may be used to point phonograph needles or it may be used as marketable goods to make money for the Tiffany company, but these are not the intrinsic value and poetry of it, nor the sapphire blue. Rockwell Kent may make pictures for soap advertisements, but the icy dream and beauty of his pictures are not advertising. Nor is the art that

made them advertising. He may even make pictures of soap with somber whorls and vortices of suds sucking down into infinity, or he may paint revolutionary words in Eskimo into Caribbean murals where all may read them, but even then, I think, his art cannot be called either advertising or propaganda. What it is, as art, is not what it may be used for. If propaganda enters into the content of the poem, its persuasive power for an ulterior end is still external to its value as art.

For art is an identification in something. Propaganda establishes an ulterior relationship to it or to something beyond it. Art is mystical and participatory. Propaganda is discursive, rational. In essence propaganda is the use of one thing for some ulterior thing. Poetry is incapable of that attitude.

It is customary for the proponents of propaganda in art to say, "Well, of course art need not always sell soap or campaign for the next election, but poets' and other peoples' lives in their texture and content are struggles for a better world or for this other thing or that. Aesthetic values cannot properly be detached from the significant content of life, and art will express it." And that, I think, is true. But that is not propaganda.

Propaganda cannot be identified with significant expression. It involves, by definition, the deliberate subordination of artistic or other activity to some ulterior end. It is a practical or instrumental type of activity that entails shrewdness, planning, often deception. It is recognized as such by its proponents at the beginning of an argument. At the end, however, they usually are trying to identify it with any serious expression, any mature formulation in art. Thus by unnoticed degrees they would incorporate all art, all life, in a partisan philosophy of conflict. The next step, already made by some of our fashionable intellectuals, is to support institutional or state control of literature. And so the cycle is complete where the old-time Puritans, Methodists, Catholics, and others were years ago.

The poetry in *Our Little Ones*, the Sunday-school paper of yesterday's childhood, and the poetry usually published in *The New Masses* is all about the same. So also are the Nazi hymns and the Salvation Army songs. All are vitiated by the theory that they must have a moral. They must carry a message, wave a flag. Their ulterior symbolisms destroy the direct value of artistic action. Their compulsions stultify the expressive power of art.

Symbolism

The dope addict turns to what he thinks is Methodism. He sings and shouts. He makes himself ideologically correct. He becomes expert in the dialectics of his party, and in the end is far more orthodox and intolerant of other systems than good old John Wesley himself. He finds new exaltations and, though they may be fortified somewhat by occasional return to his old habit, he still out-methods the Methodists on every possible occasion. Though we may distrust somehow the convert's sudden Methodism, or Catholicism, or communism, or other doctrine that he may choose to ride, no one can talk him down.

In more than one way the propaganda school of poetry is a similar reaction from symbolism. One orange has been sucked dry; here is a fresh one. And the course of literature becomes from this point of view a succession of explorative thrills, greedy exploitation, boredom and dryness, then migration from that orange to another and a new set of thrills. So sensitive and discerning a critic as Edmund Wilson, whose mind and sincerity I respect, seems to assume in *Axel's Castle*, for example, that this is the course that poetic expression naturally runs. Unfortunately he is at least partly right, for he is dealing with literary movements that lend themselves to

such interpretation. But to assume that significant poetry which is either rhythmically or symbolically expressive of the living pattern moves thus romantically from thrill to thrill, seeking an addict's exaltation now in this formula, now in that, is to interpret the general movement of literature and life in terms of one narrow and socially isolated movement in it. Poetry of importance is not a way to stimulate the poet and his readers. Were that the case Rimbaud's retirement into crude action and Africa would be inevitable, for there is more stimulation in such events than in poetry. Far more serious than that is poetry. It is a formulation of the activity of life. It is expressive in so far as it gives form and significance to that life.

I am trying to say, though badly, that poetry is not about life nor for life. In spite of the notions of Plato and others, it is not a bottle of Scotch at life's elbow designed to intoxicate the mind and make the heart beat faster. Poetry is life. It is a significant formulation of living activity. It is life as much as memory or the action of the liver. It is rhythmic, moving, inevitable so long as life persists, and its words and symbolizations are, or should be, only ways to elaborate and enrich that direct movement. They have no status of their own as symbols, concepts, words.

When they fail in their primary intent to elaborate and give more articulate form to the living movement and rhythm of which they are a part, poetry has gone from them. We forget, those of us who read and write and talk, that living is not words, and that poetry turns to those frail substitutes for action only to make itself articulate. Its reality and origin lie far below them. In some deep, voiceless realm is the poetry without words. Words, indeed, only suggest it.

Have I come in this way, by some back pathway through the hills, to symbolism? I think not. For the realm to which I refer is action, consummatory action to be sure, but action no less. Poetry is an intuitive, mystical integration of that action, and that, I think, is a very different thing from the symbolism either of Poe or his successors, Mallarmé, Verlaine, Valéry, Eliot and others.

It is true that poetry, in my opinion, is suggestive rather than communicative. It uncovers in the reader's life, not what the poet may have thought, but what was already there in the reader. Poetry differs from prose in that it wakes the deeper life and rhythm in all people, gives it form, and in that way creates new forms of the living pattern, or reveals old ones. Prose on the other hand is a vehicle

to transport material from one mind to another; it is communicative in that sense. But poetry ignites people. It is suggestive, evocative.

Symbolism, as a school of poetry, also has abandoned objective communication but for different reasons and with different results. Symbolism, says Edmund Wilson,[3] is a studied attempt to communicate unique personal feelings by means of a complicated use of metaphors. It is marked, first, by the deliberate confusion between the perceptions of the different senses and especially by the effort to make poetic effects musical; second, by confusion between the imaginary and the real to the extent that symbolic poetry becomes even more a matter of individual sensations and emotions than does romantic poetry; third, by the use of arbitrary symbols for the poet's ideas which serve more to disguise the ideas and to create deliberate mystery and guessing than to clarify them.

A good deal of symbolic poetry, as well as some modern work that can hardly be called symbolic, abandons the element of "plain sense," or consecutive thinking, in favor of an associational order of things contiguous in the stream of consciousness. In this way it attains vivid psychological realism at the

[3] Edmund Wilson, *Axel's Castle* (New York: Charles Scribner's Sons, 1931).

expense of external realism and logical, grammatical continuity. It is also less constrained in achieving subtle tonalities and suggestions that fit awkwardly in "plain sense" patterns. Eliot's *Waste Land* is based largely on this associational pattern. Joyce's *Ulysses* is the beginning of an effort to create a new mode of communication from these inner, textural contiguities of consciousness.

This brave effort to create a new pattern of perceptual configuration on a large scale, like similar adventures in modern music and painting, may be a failure as a general campaign. But the successes of some of the battles will probably remain in our language and art after the works of the leaders in the movement are no longer read. I doubt whether the work of Joyce after *Ulysses*—if he continues the tendencies present in Finnegans Wake—will be read much now or in the future. Though Mr. Joyce no doubt gets himself expressed personally somewhat to his own satisfaction, the artistic value of the work, and it is great, will remain not in its generality, but in just that private creative activity of Mr. Joyce. His expressive terms are so individualized, so unique to the textures of his own experience, or the experience of the other inhabitants of his book, that the reader simply cannot be expected to learn the lingo,

when the next book, either by Joyce or another au-
thor, will involve the labor of learning another lingo.

Art it seems to me is artistic activity, not of other
people, but of each person himself, or of groups of
persons acting, literally acting, creatively acting, to-
gether. The generality and communicability of art
is secondary. In this sense Joyce may be more impor-
tant as an example of how to act than of what to
read. In this textural, muscular, emotional incom-
municability his work is like the dance, more some-
thing to do than to watch or read. We should each
be, in other words, our own Mr. Joyce, always creat-
ing, changing, developing our expressive life. But
this conception of art, which leads to the informal
folk arts and expressive crafts done for the doing, is
hardly suitable to romantic symbolism. I imagine
Mr. Joyce himself would be the first to repudiate my
interpretation of his value.

The Modern Movement
But the line from Poe is a thin purple that tends
to trickle out and disappear in the sands of the

modern world. Far more robust and far more impor-
tant is the tradition of Whitman in modern poetry.
Its poets are a numerous, variegated group. Their
works are both massive and lofty.

With the foundation of *Poetry, A Magazine Of
Verse*, in Chicago in 1912, modern poetry in this
greater tradition may be said to begin. It was the be-
ginning of modernism not only in one group, school,
poetic attitude, but in many. The Imagists, such as
Hilda Doolittle, Amy Lowell, John Gould Fletcher,
found early expression there. Their hard, gemlike,
slight poetry in free verse had the delicacy of a carv-
ing on shell, and the brittleness. It was passionate
and dainty, throbbing, reserved, and its rhythms
were a thin knife edge of movement making free de-
signs. Such poetry, a kind of American and classical
variant of French romantic symbolism, was as
equally at home among the origins of *Poetry* maga-
zine as was a Sandburg or a Lindsay.

The editor and founder, Harriet Monroe, accom-
plished in this little magazine a rare thing. Upon this
vehicle, poetry of all sorts rode to recognition and
significance. A tradition was established in which
poetry still flourishes twenty-five years and more
after. Harriet Monroe never founded a school, lim-
ited to certain kinds of members, but in founding a

vehicle that she operated with liberal good taste and a genius for significant discovery, she started many careers in different schools on their way. Her artistic tolerance and democracy joined with her intensity of effort to help poets express themselves was the unique reason for the magazine's success. The list of poets who first found publication there reads like a Who's Who of modernism.

These poets, who fairly may be said to be the modern movement from 1912 to the present, or at least to represent it overwhelmingly, may be characterized roughly as follows: Rhythmic form in their work abandons metrical necessities and becomes a flexible pattern of movement. It is a movement closely associated with the tonal and symbolic material of the poem. Though metrical poetry is used when the poem seems to demand it, metrics no longer are required. Conventional poetry was a more or less complicated interweaving of rhythms marked by poetic feet, phrases, lines, caesuras, periods and the like, but modern poetry is likely to turn to the phrase, or cadence, as the rhythmic base. These cadences are in delicate but variable adjustment to each other. They move informally, sometimes rhapsodically, through the poem. They incorporate in themselves tonal effects which are as much rhythmic as tonal

in consequence. The cadence indeed may become a subtle fusion of tone and movement that expresses, almost without word meanings, the poetic reality desired. Every particular thing has its cadence. The poet somehow discovers it.

To write such verse requires a delicate and always fresh sense of tone and rhythm on the part of the poet. No metrical framework upholds him. No golden cage of measured verse is there to receive his poetic canaries. He must create afresh each time. His ear must always be alert. It is easy to write bad modern verse, but to write good modern verse is harder than in the old conventional forms. Not only is modern verse form more free than conventional verse, it is more closely adapted, like the skin to the body, to its material.

A third characteristic of modern verse form, at least of much of the more recent verse, is the repudiation of grammatical, sequential forms of speaking in favor of purely associational textures. Poetry becomes a fabric rather than a procession. It abandons statement. Intimation is enough.

It is much more than enough. When material is forced into orderly, sequential statements, it loses subtle qualities and suggestions, or distorts them. The rich and reverberatory verse of modern times is

possible in great part because of this new way of associating its parts with each other.

In content also modern verse is sharply different from the older kind. If content includes not only the symbolic or verbal meaning, but the entire emotional, rhythmic, appreciative burden of the verse, the modern transmutation may be described somewhat as follows: It repudiates the old gentilities. It repudiates the conventional limitations of poetry to the generally remote, the antique, the exotic and to certain stereotyped formulations of sentiment that were supposed to be universal—universally dead I should say. All this it repudiates in favor of material that is present in time, present in geography, present psychologically. Once Chicago was too much present in time, too much here, too much present in the eyes, ears, nose, to be the subject of poetry. But Sandburg and the Chicago school changed all that. Once the stockyards were not sufficiently genteel to enter the doors of verse. That too was changed. Poetry now considers all significant material its province. The dusk of distance and gentility gives way to the lighted present with all its harsh angularity. Poetry in that general sense is naturalistic.

Modern poetry is also psychologically naturalistic. Not only outer but inner realism is taken for granted.

Once the inner frankness and obscenity of the mind was closed to poetry. Once, indeed, all materials that had the color of earth and honesty were unknown within its precincts. But the psychological world as well as the world of outer events has broadened, deepened, become frank. Modern poetry accepts that change, enters it, elaborates it.

In terms of content, modern poetry may be tentatively divided into three groups. They are not well defined groups. The poets in them overlap the groups, nor are they in a clear order of succession. The first of these groups is generally concerned with human and social expression. Humanist poets in this group flourished best in the early days of the new movement. Masters, Frost, Sandburg, belong in general to this group.

The second group includes poets whose main interest lies in the aesthetic and in the experimental. Here are most of the neosymbolists whom I discussed before. Others concerned with problems of form and of the more purely aesthetic effects are also here. Wallace Stevens, T. S. Eliot, Ezra Pound, Conrad Aiken usually belong here. These poets flourished early in the new movement, but rose to their height perhaps in the middle period. The Imagists belong here as well as much of Vachel Lindsay, but the group

culminated in Eliot's *Waste Land* in the early twenties.

A third group are mystical, religious and metaphysical poets. Robinson Jeffers in recent years is the culmination of this group. Lola Ridge, Hart Crane, Tagore, Walter de la Mare, Anna Hempstead Branch, Edna Millay, and, I think, even E. E. Cummings belong here.

And then to indicate the richness of the modern movement in poetry I list a few of the many poets whom I shall not try to classify: Muriel Rukeyser, Mark Turbyfill, Eunice Clark, Louis MacNeice, Mary Austin, Horace Gregory, Eunice Tietjens, Frederic Prokosch, Morton Zabel, John Crowe Ransom, Dorothy Parker, Robert Bridges, Roy Campbell, George Santayana, Rupert Brooke, Sarah Cleghorn, Babette Deutsch, Kenneth Fearing, Elinor Wylie, Edwin Markham, Marjorie Allen Seiffert, William Rose Benét, Max Eastman, Marianne Moore, Jessica Nelson North, William Carlos Williams, Harriet Monroe, Alfred Kreymborg, Baker Brownell, Margery Mansfield, James Palmer Wade, Maxwell Bodenheim, A. E. Housman, Stephen Vincent Benét, John Masefield, Malcolm Cowley, Ogden Nash, Selden Rodman, Alice Corbin Henderson, Laura Riding, Hugh MacDiarmid, Maurice Lese-

mann, Marian Strobel, Lew Sarett, William Stephens, H. H. Lewis, Richard Aldington, S. Funaroff, Marya Zaturenska, Rolfe Humphries, Louis Untermeyer, Archibald Fleming, Genevieve Taggard, Edwin Rolfe, Jean Toomer, Glenn Ward Dresbach, James Stephens, Haniel Long, Hermann Hagedorn, Percy MacKaye, Elizabeth Madox Roberts, Oscar Williams, Witter Bynner. There are many more. A number of them are poets of general importance. There is, indeed, no lack of poets in this age.

But names are not poetry, nor are classifications. And I am quite willing to undermine the whole motive of this book by saying that the endless talking about poetry, about music, about the dance, about art in general is only a little better than useless. It may have some value in making articulate the world we live in and giving it intellectual continuity, but all that is secondary to direct expressive activity itself. Nor am I sure that reading the poetry of other people, singing other people's songs is all that it is cracked up to be. Fortunately from the nature of things we cannot dance other people's dances, at least not very much. And to find our own poetry and express it, though it be only a rhapsodic phrase, is better than many books. A child's unrecorded song is nearer art than my performance of other people's music, however elegant.

I might well quote some poetry, I suppose, as examples of the groups and tendencies and great fires of the modern art. But why go through that pedantic routine of comment and example, comment and example? It were better for the reader, and for the book, if he will make his own. It has become troublesome, moreover, under the jealous stringencies of the copyright, to quote anything, even a line where full credit is given. So touchy have publishers and authors become, behind these literary and intellectual tariff walls, that the natural flow and interchange of ideas is endangered. But only artificial poetry, after all, is thus confined. Authentic poetry is not in books but in living action.

The modern movement in this respect is encouraging. With the advent of *Poetry*, the magazine, and the new movement, poetry escaped the hands of the professionals. Freer forms and native content gave it once more to the thousands of people to whom it rightfully belongs. The modern dance became a great popular movement, almost an obsession. Modern music, at least the instrumental performance of it by boys' bands, orchestras, informal music groups, as well as by individual amateur musicians, also became a widespread activity throughout America. In the same way poetry in the last twenty-five years has been taken up by thousands. Ten thousand folk were

writing verse in 1920, I think, where one was writing in 1910; and fifty poets of general literary significance were flourishing in 1925 where one existed in 1910. I do not try to justify the ten thousand amateur poets by the fifty poets of general importance, although I think the causal connection is evident. I say merely that ten thousand folk writing poetry informally because they want to is a literary event of major importance. And that, even without a line published for general circulation!

Poets of Other People

Four poets broke the front of academicism and indifference and, just before the Great War, made poetry in America a matter of general interest. They carried poetry in upon their backs. They are Carl Sandburg, Edgar Lee Masters, Robert Frost, Vachel Lindsay. To these I should add Rabindranath Tagore whose *Gitanjali* in English with an introduction by Yeats was published then, and Edwin Arlington Robinson who was already established. But without these **four horsemen of the new apocalypse I doubt**

whether the poetic movement would have been
any more massive than other things that come and
go.

These four have little in common from a critical
point of view but, different as they are, as Americans
and moderns they are in effect one poet. Masters is
a graveyard prophet of a middle western small town.
All the death and whispers of the place gather to tell
their stories. The poems are abstractions, fragments,
from the level life and macabre morals of the Illinois
community. They are abstractions as death is an ab-
straction from life, as evil and the sour stench of
hatred are abstractions, and they are told in cold,
boxlike verses one after another through the course
of the *Spoon River Anthology*. The traveler who
goes now to central Illinois finds the burial ground
on a slope beside the river a mile or so from town.
The concrete road cuts through another burial
ground, smaller, abandoned by all but the dead and
the cattle that browse across the graves. Five miles
away another burial ground older than either lies
on a hilltop. It is an Indian graveyard, carefully exca-
vated now, every bone visible and in place, every
trinket and bowl revealed. The child's bones are
surrounded by the mother's. The dead of plague lie
in their ancient order.

Masters' poetry is a bone revealing place like the ancient Indian hill. The harsher substrata of life are there, the coarser gravels, the dead skulls. Sex is a grim persistence. Greed and moneyed pride are swollen carcasses by the Spoon river. Meanness and hatred; and there is sweetness too, although readers rarely remember it.

Sandburg's poetry is less hard but more angry. It is mystical, tender, bitter, harsh. The grim monotones of Masters are variegated voices in Sandburg. Crash and gentleness, blazing, cloudy. In this Swede there is a subtle sense of tone that Masters never used. He sings and shouts. His voice in lectures reels up, spiraling, and sinks down, but Masters never sings. Sandburg's early books, *Chicago Poems, Cornhuskers, Smoke and Steel,* are poems of people, always of people, always of other people, never himself. His loves, sympathies, angers always are outgoing.

This is true of all the poets in this group, or nearly all, and is a characteristic, I think, of their human and social interest. With Tagore comes the personal —and eternal—vision of religious insight. With Millay comes the romantic self-concern of young women and love. But in Masters, Sandburg, Frost, Lindsay, Robinson, there is little personal concern poetically, nor much romantic, self-reflecting love.

If the song of this self-reflecting love be what critics call the lyric, these men are not lyrical.

Frost has a subtler darkness and decay than Masters, a pessimism more refined but more heartbreaking, more sweet, more hopeless. For Masters is the poet of a decayed community, Frost of a failing stock. Masters sees the shadow of doom, but his folk are hard, cruel, responsible for their destiny. Frost sees good people, with the essential sweetness and dignity of the old stock, going slowly down to inevitable defeat. His delicate rhythm and reticence, his daylight and the human suggestiveness of his plain words have made him for many critics of different schools the foremost poet of the time. Like Masters he is rather a one-book man. He never has surpassed his *North of Boston*.

Lindsay is a puritan Dionysius. He comes dancing, rapt and gay from Springfield, Illinois. His poetry always is tipping over into music. Had he the advantage of a Paris education, like many another poet of these times, he might have known what he is doing, but his work would not be poetry. He has true naïveté, a rustic union with the gesture and rhythm of his folk and time. Lindsay, and sometimes Sandburg, are more identified with their folk and culture than are Masters and Frost. They speak from them not of them.

Robinson, more traditional than these other four, is the main bridge between the old and the new. His intellectual comment, his classic—and New England—tightness and continuity belong to an old generation. His realism and objectivity, the modern significance of his subject matter, the crispness and movement even of his Arthurian poems indicate his modernism. And Robinson, too, like Masters, Sandburg, Frost, Lindsay, looks upon things in their own terms. He rarely makes the romantic transmutation. He remains objective. Rarely do things speak in other than their own voices.

These poets of people stand on the simple earth. "Here are people," they say, "Hod Put, Daisy Frazier, John Brown, The Mayor of Gary, The Hired Man, Miniver Cheevy, these are our interests. Are they happy? Are they cruel? Are they defeated? What is life for them?" They assume with naïve courage that man has a native right to a good life. They assume that he is important, and as they watch his progress they are angry or downcast, gay or morose with his success or failure. They watch the human drama less as a spectator in a box seat at the theater than as a person following the bulletins of battle in which his folk are fighting. They are not detached. Though naturalistic they are not classical in temper. They are involved in their human material, and

what they say about it is thus prophetically important. The age has produced many of these poets. They have nobility. Their mood and fortune rise and fall with human fate.

Poets of Self

A second type of modern poetry is concerned less with people than with aesthetic perception as such, and with technical experiment. Some of this poetry is in the traditional line of Poe and the French symbolists, some of it has other origins. Where the poets of people have a spaciousness of interest—for people after all are a broad and tumultuous world—the poets interested mainly in their own aesthetic perception limit their range. They refine their field and seek in an intense focus or the thrill and poignant fire of a symbol all that is significant in larger, more massive work. They resent discursiveness and the clash and clutter of a large world. And though it is true that their fear of vulgarity is sometimes more of a formulating principle in their work than intensity of insight, they are at least partly right

in insisting that poetry should not be discursive and journalistic.

What is this beauty that they so lonely seek? Their seeking, I think, is a large part of it. Before the Crow Indian becomes fully a brave, he must have a vision in which he finds his manhood name and future. As the time comes the young buck begins to starve himself. He wanders out onto the plain and desert. For days or weeks he stays removed. His hunger grows like a white wall around him. Then the vision comes, or he thinks it comes. The young man is admitted to maturity.

In rather the same way do these poets seek beauty. They reject the rough food of casual, human experience, or find themselves unable to digest it. They reject the hetero-poetic world, or are unable to find it. They turn to the desert's forty days to find what the live, waiting soil did not give. Often their poetry springs from critical disciplines and doctrines and deliberate aesthetics, doctrines either of their own elaboration or of a supporting critic, rigorous, confident, cold, such as I. A. Richards.[4] I could go on, were it fair, to suggest that their regimen and seeking causes, more than discovers, the beauty that they find. Lonely seeking, lonely art, lonely poets.

[4] See I. A. Richards, *Principles of Literary Criticism* (New York: Harcourt, Brace and Company, 1924).

By what right, however, do I make aspersions on a group of poets because their interests seem to me narrowly aesthetic rather than humane or religious? By no right whatever, and if they find poetry there in deeper movements, deeper formulations than they find elsewhere, good luck to them. As a fact some of the most fascinating and delightful work of modern times or any time has been produced by members of this group. Wallace Stevens, Allen Tate, E. E. Cummings, Conrad Aiken, T. S. Eliot, Ezra Pound, W. B. Yeats, Hilda Doolittle, W. H. Auden, D. H. Lawrence, George Dillon, C. Day Lewis, Stephen Spender, Archibald MacLeish, Amy Lowell, all are more or less, or at one time or another, members of this group. They and many others. It is no group of minor poets. And in spite of themselves they have social significance as representatives of one aspect of this age.

These poets are roughly of two sorts. For one the aesthetic perception is mainly in objects, events, and fantasies of them. For the other the aesthetic interest is self-consciously in the poet's own personalization of experience. It is a romantic coloring of reality with the pale cast of self. Just what this romantic introversion of experience may be, I do not know. I have said that the value of things is the bearing that

they have on our life and interests. Possibly this introversion of experience is an elaboration of the evaluating process beyond values and relativities to a point where all aspects of reality are personalized. In any case the romantic attitude among these poets is in clear contrast with poets who, for want of a better term, may be called classical-minded. Ezra Pound, Wallace Stevens, Archibald MacLeish, and perhaps W. H. Auden and William Butler Yeats are aesthetic poets with a classical turn of mind. Conrad Aiken, T. S. Eliot, and perhaps D. H. Lawrence and E. E. Cummings are more romantic-minded. I am not sure that these are good classifications of poets, but they do apply to poetic attitudes.

Ezra Pound is one of the earliest and eternally adolescent of the new poets. His work is oddly discontinuous and brittle, always fresh, always experimental. It is Pound's fate to originate work that other people do better. He starts many an elevator in the new temple of the muses, but rarely rides up in one himself. Like Eliot he is full of fictitious learning, and in many a poem raises a scattered façade of multilingual quotations that rather obscures what may or may not be behind. His work is without passion, without sentimentality or emotional afflatus, without romance. It is hard, delicate, stubborn poetry that is

intellectual in temper though without great intellectual content. To Pound we should be grateful for his persistent freshness and boyish experimentation. He is a poet's poet, a bright, courageous spark.

Wallace Stevens' gay delicacy and casualness give his work an aesthetic balance that none other in this group has. His subtle patterns are not overworked. They bear their proper burden according to their stature. Cool nuance of line and subtle color, the light thrust, mark his work. There are no responsibilities here, no burden, no pressures. Poetry for the fun of it, and for that reason pure poetry, poetry without pretense or ambition. No modern work is more charming. And he too is a poet's poet.

Archibald MacLeish began as a symbolist but found it too small for him. He is one of the few in this group who changed successfully to social poetry. The success no doubt was due to the fact that MacLeish in both cases was master of his method and theory. They never mastered him. His work always is under control. There always is reserve. The one-time Hamlet of A. MacLeish has forgotten himself. He is now the most powerful of the new liberal poets in contrast to the New York variety of communism in literature.

W. H. Auden, whose name always is coupled with

Spender and Day Lewis, is another still younger sym-
bolist who has turned to social poetry. His poetic
ancestry is numerous and varied, from Gerard Man-
ley Hopkins to T. S. Eliot. But the war in Spain and
reaction in Europe have broken through the crust of
symbols and obscurity of his early work in England
and discovered a man. That has not always been the
case when symbolism and Fate have met.

And William Butler Yeats, the grand old man of
English poetry, now gone; how strange that this elfin
Irish poet, fiery, mystical, should acquire such a
status! His work has many phases. Much of it is a
kind of fairy symbolism, an Irish night of strange in-
sights and brilliance, that no other poet approaches.
Though his color and texture are romantic through
and through, I have placed him with this group of
classically minded poets, because of his absorption
in things other than his own personally bounded
sphere. But I am doubtful about him and Auden and
many another in this job of pigeonholing.

Of romantic poets in the aesthetic group, Conrad
Aiken is one of the most interesting. His is a melody
of modern chaos, as Houston Peterson shows. Deli-
cate, desperate, absorbed in purple abstractions of
death, his work expresses, more than any other that I
know, the doom that the modern world lays on the

sensitive and spiritual mind. For Aiken is a spiritual poet, whatever that may mean, and though it is a spirituality fused with the insoluble problems of the self and of beauty—problems in that such minds make them so—it has deep fire.

As a celebrity and an influence on other poets T. S. Eliot is more important, I think, than as a poet in himself. He has become an often quoted type of post-war spiritual defeat. Though Pound, Aiken and the French symbolists preceded him in some of his best known work, it was Eliot who became known. Fame is a rattlesnake that usually strikes the second in line through the grass.

Eliot's poetry lacks the qualities that make a man or poet beloved. It lacks nobility, generosity, kindness. It is snobbish, hard, hopeless. It is self-tortured, writhing from the absorption of its own poisons. But it has distinction, and that, I think, is all that many members of this group desire. "Away with this plush of fine sentiments," they say, "we have seen them fail. Here is the cinder field behind them." His lines have cruel beauty and memorable phrase. They sting and coil, or slide sinuously away.

Having burned through the cardboard ideals and hypocrisy of the great war and its aftermath called peace, Eliot's poetry, tired perhaps, or seeking secu-

rity for a sick soul of the lost generation, turns to other cardboard ideals for refuge, and again finds peace, or at least what passes for it. His later poetry is strangely incongruous with the poetry of his early and middle period—and strangely unconvincing. He becomes, indeed, a classicist in literature, an Anglo-Catholic in religion, a royalist in politics, or so he says. I doubt, however, whether any of these can be picked out, like a new suit in a department store, and worn home. The tailoring is faintly ready-made, however well done, and the style, though very, very English, is rather vulgar under the circumstances.

England is traditionally a climber's paradise not only for American millionaires and their daughters but for some poets and literary men as well. I refer not to the personal lives of the literary men, of which I know nothing, but to the artistic ideals expressed in their work. In realization of these ideals England offers status, security, a bit of arrogance perhaps, and a sense of being here, here, at the top of the ladder, level by level, all the way from Mid-America. And the longing of able but sensitive and civilized folk for a more appropriate environment is easily understood. The academic type of civilization, always focused somewhere else, now Greece, now Paris, now England, now Russia, anywhere but in the lives of

people here, intensifies this nostalgia. Whoever takes this "cultural" schooling seriously is bound to leave these unenlightened shores for realms where truth seems sweeter, at least to a visitor, and art seems nearer daily bread. But those who enter there pay a heavy cost. Fortunately they not often are aware of it.

D. H. Lawrence was among the early Imagists, a group of experimental importance, that was too limited technically to give much scope for development. At that time Pound also was an Imagist. Amy Lowell, John Gould Fletcher, Hilda Doolittle, Richard Aldington, were others. Their hard, concrete images, their modern terminology, their lean and economical but subtle lines, became examples for much of the poetry that followed. Lawrence, however, rather grew away from the group and in his prose and poetry moved nearer and nearer to mystical, religious exaltation. He finds it burning with white flame in the sun, in sex and in animal life.

E. E. Cummings comes to the bright land of pure poetry more often, perhaps, than any of his fellows in this group. He is a wise-cracking little saint—I refer to his poetry—whose brilliance of metaphor and glow is thrilling to the reader. I call him saint because of his mystic light and penetration. It is a small-scale sainthood, to be sure, but no less saintly.

His jokes, his casual privy talk, his comment on wet dreams, etc., etc., his innuendos and his odd lines without capitals left here and there on the page like the droppings of a bird, keep him from the recognition that he deserves.

There are many poets in this group. Of all of them Wallace Stevens and E. E. Cummings are the most purely poetic in the aesthetic sense. Here form and content are relevant to each other. Here are dainty balance and imagination, aesthetic purity. Here is gay alertness to the shimmer and twitch of the real. Here is freedom from schools, influences, movements, philosophies. These poets have courage, indeed, to forget the burden. And as poets they have unique and organic perfection.

This kind of poetry is appropriate to such a group. We should be grateful to these poets who can be what they are.

Poets of God

A third type of modern poetry is mystical and religious. It dominates this third decade of the new

movement, and includes, I think, some poets of major status. Robinson Jeffers and Rabindranath Tagore are two of these. Other mystics are Lola Ridge, Hart Crane, Anna Hempstead Branch, Walter de la Mare, Genevieve Taggard, Edna St. Vincent Millay, D. H. Lawrence, Cloyd Head, E. E. Cummings, Carl Sandburg. If the aesthetic poets are characterized by their method and their attitude towards personal experience, the mystics are marked by the temper of their life and thought. The former are perceptive and discriminatory. The latter transmute their material and participate in it. The self of the romanticists disappears, and the objects of the scientist and classicist disappear, the mystic finds in primordial identification his integrity of being. He becomes the deep rhythm. In his participation in things, in his intuitive ability to be identified with them, the mystic finds what seems to him the essential character, not only of art, but of love, religion, laughter, all appreciative life.

Tagore, indeed, expresses God in the terminology of love. His most important poem, *Gitanjali,* is done in mist and dream, though withal it is articulate enough. "There art Thou," he seems to say in one parable after another, metaphors of God. And in each turn he finds God anew. It is not easy to say just

what the mystic is doing. He finds within the concrete presence of this event or that, an appreciative finality that gives him joy. And this to him is not only a perception of beauty, it is being there at the heart of it; and not only at the heart of one but at the heart of all. He enters God, as Tagore might say, or God enters him. What is the difference?

Tagore's poetry is written both in Bengali and in English by Tagore himself. The English version is in soft, non-metrical verse, gently rhapsodic in character. Most of this work was published early in the new movement and was widely read. *Gitanjali* might well be a devotional book like the *Theologia Germanica* or some of Eckhart's sermons. Its spirit is devotion, never detachment. Eckhart, indeed, and the unknown author of the *Theologia Germanica* are fellow spirits with Tagore.

Where Tagore has sweetness, Robinson Jeffers has violence and terror, but the two are not dissimilar. For they alike look beyond this frame of particular things and pluralities. They look through this frame or into it and alike find in concrete things the final fire. Do my terms make this mystical attitude seem remote and fantastic? As a theory of reality it has as much validity as any other. As a metaphysics it has as much common sense as realism, materialism, ideal-

ism, rationalism and other respectable philosophies. Perhaps it has more. But theory and metaphysics to the mystic are not important. He is concerned only with his presence in real things. He is wrapped in the immediacy of life and events. "Here is the real, if you must ask," he says, "here in this life and movement."

Robinson Jeffers is a poet of action and fire. And in action and fire all values, all sanities and hopes at last are consumed. Life is fire, death is fire, existence itself is fire. They burn across the world. Jeffers is a California poet on a headland over the Pacific, and he sees the modern world as a process of self-destruction, cosmic incest turning inward upon itself, burning in its own flame. This symbol of incest moves through his poems. The longer California narratives, *The Women at Point Sur, Tamar, The Roan Stallion, Cawdor, Give Your Heart to the Hawks,* are among his more important works. In them the tragic motif is worked out as it is worked out in the Greek dramatists, in Shakespeare. Fate awaits mankind. But fate is not external as with the Greeks. It is the inner fate and fire of man himself that destroys him.

Man indeed is beyond all a wild, primordial flame. Before it a veil or screen of sanity is upraised. Morals,

order, the conventions of the commonplace are erected to confine it for a while. But they are burned through. In a fiery realm beyond good and evil, beyond sanity and order, the essential madness of reality is revealed. Order is an artifice, sanity an invention of the moment. They are man-made patterns that last here superficially only for a brief time. Behind them are the flames.

What are these troubles and perturbations in man's career? We usually think of them as casual errors and accidents of a life embedded in a vast moral and cosmic order. Not so Jeffers. For him they are irruptions into our local order and sanity by the vast disorder and madness about.

This at least is what his poetry means, though I confess I do not know what Jeffers himself would say about it. "In western literature three great expressions of the tragedy of man have been made. They are Greek tragedy, Shakespearean tragedy and the tragic narratives of Robinson Jeffers," says Alpheus Smith, a critic whose opinions deserve respect. Later I shall show that Eugene O'Neill and some of the post-impressionist painters have somewhat the same vision of life. But of all modern tragic expressions that of Jeffers is the most penetrating and powerful.

Lola Ridge is a poet of much the same temper and

spiritual experience as Jeffers. She is a mystic with a magnificent metaphor that transmutes all things that it touches. Her long poem, *Firehead,* is a tumultuous stream and storm of these transmuting metaphors that leave the reader dazed with their beauty but not entirely clear as to what was said. Her lesser poems of streets and proletarians have grim power, beauty, compassion.

Anna Hempstead Branch has written at least one poem, *The Monk in the Kitchen,* that deserves a place in the small but ancient list of mystical classics. Here it is order. How different from Jeffers! It is order as a domestic Plato might see it, form as an entity in which this Brother Lawrence can participate. Into this order the mystic enters. For mysticism is as variable in expression as it is constant in its central vision. If Jeffers may be called a dynamic mystic, Anna Hempstead Branch is a mystic of a more classic type.

And Hart Crane in such a category would be rather a psychological mystic. He too sees the world disorder, but where Jeffers faces events, actions, people, Crane expresses the inner disorder of a stream of thinking. Symbolic disorder, cross rips and broken tides of introversion.

Edna St. Vincent Millay is also a mystic in one

major poem, *Renascence*. It was written early in her life; she has never since found so deep water. Why should she? Her later work, her girlhood, her womanhood, her white glowing sonnets, are more a poetry of people or of purely aesthetic perception than mystical and religious. Youth is the season for religion, philosophy, deep waters. Events and people usually capture a life thereafter.

But modern poetry is a great and variegated movement. Though its diversity is unprecedented, I think, in the history of art, it is by no means the eclectic hodgepodge that was found until recently in architecture. Modern poetry is authoritative, expressive. Its diversity indicates not weakness but a complicated world in which different cultures and attitudes exist beside each other.

VIII. The Drama, the Novel, the Movie

THE drama is half dance, half poetry. The novel is drama in which the action or dance is symbolized. It is ghost drama. The movie is the dance in two dimensions, seen and heard as in the theater, but rarely felt kinesthetically. I shall deal with all of them here briefly as one. Of them all the amateur drama, in which the main thing is taking a part, is artistically the most important. I rather dread the growth of art that resorts more and more to symbolization and substitution in place of action and moving, muscular rhythm. But I must accept them. The course of present civilization, for good or bad, seems to be that way.

Historically the modern movement in this general field is marked by the wide dispersion of amateur playhouse groups, by the decline of Ibsen, the fixation of Shaw, the emergence of O'Neill as dramatists, and the rise of Gordon Craig as designer, by the elaboration and great popularization of the movie and the radio play, and by the final flowering and wilting of the novel. Are these but scattered and separate events? I think not. They are correlated closely with the movement of the times and with each other.

The amateur theater, like the wide diffusion of

poetry writing and the hosts of informal orchestras and bands in America, is a massive movement in the arts that tends toward our own way of expression. Maurice Browne in Chicago, Zona Gale in Wisconsin, the Provincetown Players, George Cram Cook, Stuart Walker were developing the small theater in much the way that Harriet Monroe and her associates were developing modern poetry, and at about the same time. Though too much energy in the amateur theater is now lavished on scene and interpretation and not enough on the creation of informal plays for more or less spontaneous acting, that I hope will come.

The art of improvisation on the stage, and I mean not the filling in of forgotten lines but the group creation of the play as it goes along, has never been adequately explored. Starting with an established character or two and a situation, why are not plays more often improvised from the action as it goes along? And this not only for purposes of training, but for public performance? In this direction creative drama will be found. We unfortunately put technical perfection before imaginative movement and creation. We need more jam sessions in the drama.

The little theater, however, will be for a long time mainly a group of people, now on the stage now in

the audience, devoted to interpretive acting. It will follow the script or the score of the play and wrangle out the way to play it, good or bad. Usually it is bad from the professional point of view. But such informal and flexible efforts are, nevertheless, in the best sense artistic activity. I could enlarge on its social value in group cooperation, discipline, and collective artistic life, for these are important, but I shall try to stay more or less with art. The little theater, such, for example, as Cloyd Head's Miami Players, is one of the best modern instruments towards informal art. There is hardly a town of twenty thousand or a school without one.

On the larger stage two playwrights are dominant. Bernard Shaw's plays are still seen to some extent, read more, and quoted without reading still more. As an artist and an influence he has reached the point of fixation. The other playwright is Eugene O'Neill. There also are Maxwell Anderson, T. S. Eliot and others returning to dramatic verse, and there are Clifford Odets and some of the Federal Theater Projects bringing "social" drama of high order.

Though Ibsen, Shaw, O'Neill, says Shelden Cheney,[1] all are realistic, I would question this.

[1] Shelden Cheney, *The Theatre* (New York: Longmans, Green & Co., 1935).

Realistic they are indeed in contrast to the romantics. But Shaw, I think, is more rational or witty-rational than realistic. He is not close to earth nor very close to people. His folk are ideas and are related to each other by ideas, as real folk never are.

O'Neill on the other hand is more a mystic and a psychologist than a realist. Like Jeffers, he too has re-created the tragic situation of the Greek drama in modern terms. Unlike Jeffers he has developed this father-daughter, mother-son pattern of incest less in terms of poetic participation and cosmic symbolism than in frankly psychological terms. He dramatizes Freud. But beyond his psychology lies human nature, which for him is neither rational nor realistic, at least not in the usual sense of these words. The people in his plays are the drift of flames in the wind under the compulsions of their own burning. They blaze, they waver, smoke, or stream up suddenly now from one part of the scene, now from another. What are these flames of human life drifting together or drifting apart and fading away? I don't know. Neither does O'Neill. Life is a chance convention of fires. They weave and flare remotely under compulsions that no one can explain.

O'Neill, it is true, is sometimes called metaphysical rather than mystical. Some of the poets too, Gene-

vieve Taggard for example, whom I have called mystical, consider themselves metaphysical. I shall not quarrel about the word, and if they mean by metaphysical any realm beyond the physical phenomena and objectivities of our scientific mode of thinking, I shall not protest. To me the word metaphysical refers to an effort of the reason to carry its analysis beyond purely physical terms. The word mystical, on the other hand, refers to an "intuitive" penetration of the situation. It is insight, not reason. It is involved in value, not merely mathematical relationship. In this mystical participation or identification the ancient and disintegrative dualities of matter and spirit, instrument and end, subject and object, body and soul become what we should all along have known, merely adjectives. But again I am not clear. Mysticism is a much abused word, which because of its abuses, many people dread to have pinned on them. Others use it as an invective for almost anything that they dislike. It should not be explained as I have tried to do, only expressed. It belongs to poetry and the other arts.

Drama is life formulated in action, and through action, rather than words and concepts, it should express what it is. The small regional theater is more appropriate to characteristic and living action in this

sense than is the universal stage of the metropolis. In the regional theater action has its own native content and connotation. It has imaginative context that the metropolitan stage must replace by words or generalized stereotypes of movement. Action has relevance and character in country places and small regions. It is organic and is within the scope of human and muscular power. It is scaled to man.

For this reason much of the best work in modern drama, both in acting and writing, has originated in the local or regional playhouse. It is no accident that Eugene O'Neill began his career with the Provincetown Players or that Zona Gale was associated in her early work with her regional Wisconsin group. Nor is it an accident that the Moscow Art Theatre playing, let us say, Chekhov's *The Cherry Orchard*, or the Irish Players with Yeats, Synge and Lady Gregory, have produced much of the finest modern work. It is scaled there to man, as all art should be.

The drama is best as a regional art. This may seem paradoxical when the great city theater of the past and present is considered. But it is true. The city does little more than magnify the action of smaller places, and corrupt them. That I am afraid may be the case not only in drama but any other art.

The Movie

In the movie dramatic art is enormously extended in range. It is landscaped drama. The ancient unities of time, place, action and character are expanded in huge discursive campaigns of movement or are abandoned altogether. If the movie gains in range, however, it loses in dimension. The movie is two-dimensional drama. Though it might well be of creative interest to little movie groups corresponding to little theater groups, the movie in fact is almost entirely a professional monopoly. It comes, costly, romantic, spectacular, imitating in two dimensions with great range what the stage drama does in three. It is a sit-down art, so far as the audience is concerned, a dark-room art, a sessile watching of what the shadows of other people do. It is Plato's cave, the delight of bound souls. It is the most popular of commercialized pastimes for an urban people in whom productive and consuming activities are sharply differentiated.

It is unfortunate in some ways that the movie should imitate the drama and the novel, compete with them and drive them out of business. For the movie is so unique as an instrument that it might better be the basis of an art in its own right. Time and space are no limitations on it. Light, color,

sound, movement, all are under flexible control. Its facilities for an art of abstract design in fused sound and visual effects are unrivaled, were a composer romantic enough nowadays to attempt it. It is capable of condensation, expansions, symbolizations as is no other instrument. It can invent time, turn space inside out, fixate action or repeat it. The movie needs a Maurice Browne or a Gordon Craig; it needs an experimental, artistic genius without commercial interest.

But the motion picture will very likely continue in the lines that it now moves. It has produced great artists. Charlie Chaplin is one. Walt Disney is another. Disney indeed is one of the most significant artists in all contemporary life. He has recognized the unique capacities of movie technique and has produced through them a new and profound art. It is humane, or sub-humane, mousey, doggy, ducky, piggy as the case may be, but it has more than human humor and action. It has transcendental humor and action. Disney escapes the pedestrian limits of space and time, and by motion picture technique becomes metaphysical. Mickey Mouse is among the significant philosophical works produced since *Alice in Wonderland.* That might surprise Mr. Disney having a good time with a silly symphony, but philosophical

expressiveness and formulation may be through other means than words. Insight is not always verbal.

The Novel

The novel is dramatic art expanded to an even greater range than in the movie. In compensation it has not three, nor even two, dimensions but only one, time and symbols, or time in symbols. Its range includes not only all time and space and landscape, but all comment, philosophies and other intonations of life. Though biography in recent years has tended to supplant the novel somewhat, the novel remains primarily fictional without the grace of actual action to discipline its fictions and make them real.

What right we have as novelists to manipulate the inhabitants of our books, or to manipulate their symbols, I do not know. Amusing it is, I grant, both for the writer and the reader to escape the conditions and controls of nature and human stubbornness and to create character as they may desire. But this is an easy way to art, or pseudo-art, it seems to me. That the novel has had a large place in literature

I cannot deny. And when I read work by Thomas Mann, or Rolland, or Proust, or Sherwood Anderson, or Thomas Wolfe, I cannot deny its artistic power. Still it is hard for me to see why it is an art.

More than any of the arts of literature the novel is vicarious in action, symbolic in method. Its rhythm is indirect or secondary. It has no voice. It is rarely read aloud. It avoids control of concrete reality of things, or at least accepts reality only in an advisory capacity. Still we like it, read it, quote it. It shapes our actions, not directly, but by example and precept. Since it does not directly enter our activities to any great extent but influences them from a distance, perhaps it should be called, not an art, but an educational institution. But this I know is not acceptable.

The novel I think shows signs of decline. Fiction after all is a rather crude type of invention that does not hold up well in times of stress. A deeper, more direct and active expression is required. Already the novel seems to have exhausted its field. Though fictions, it would seem, have no limits, they become, nevertheless, stereotyped in time. And do we not tire of these unrealities? The novel I think is a product of a romantic mood of escape, or at least of some evasion of reality. It is an easy way to power over

imagined people and events that has about reached
the climax of its illusion. I think that its significance,
if not its vogue, is about over. But who knows? When
has maturity and stress made human folk reject their
illusions? I dare not predict.

Poetry and Prose

There is more in literature, of course, than these
few pages can suggest. Biography, history, criticism,
philosophy, the field of written verbal symbolization
is endless. And Santayana the philosopher writes like
a poet, until he writes a novel. And Marianne Moore,
an authentic poet, writes like a philosopher. So it
goes. The jars and caskets into which literature is
poured, history, criticism, biography and so on, do
not have consistent contents.

Literature I think has two main divisions, poetry
and prose. These are not distinguished by length of
line, or rhymes, or meter, or flowered language.
Poetry is primarily suggestive. It is a spark that sets
aflame fuels that are already there. It is a dynamic
tension. It is a formulation of action of consumma-

tory value. All this poetry is. It comes down to something like MacLeish's statement: "A poem should not mean but be."

Poetry in other words is not limited to certain compartments of literature labeled "Poetry," nor to certain forms of line structure, printing and paragraphing. Poetry may be anywhere. Where there is imaginative transformation there is poetry. The German word *Gedicht* refers to poetry in this general sense.

Prose on the other hand is literature devoted to the transfer of factual and ideal content from one mind to the other. It too has its standards. In many ways it approaches an art, the homely, solid art of the craft. Prose may be rhymed and versified, as in the ancient catechism, and though it still remains prosaic, it probably is bad prose. Prose is dependent almost entirely on the symbolic content of words. Poetry may create its values almost without such content.

Thus prose and poetry. Life and literature are alike in finding them closely interwoven.

IX. Architecture

ARCHITECTURE is also an art of action. Though its memorials, fixed by the slow crystallization of time, are given more attention than the building, using and living process, the process is the art, not gazing at its products. I have discussed before this a way in which architecture may be an art of action. It creates patterns of activity for those who live in its buildings. It writes the figure of a dance that all who enter must perform. This art is not the building itself but the muscular compulsion that it lays on the inhabitants.[1]

But what of building and buildings? First I would say that the completed, static building, though practically important in fulfilling whatever its function may be, is artistically less important than the activities of its design and construction and of its use and decline. It also is less important than the inner activities of the building in cooperation with the people in it. Buildings today are active. They are organizations of going machines. The material structures of architecture, the stone, the wood, steel, brick, glass, are symptoms of this activity and secondary to it. For the

[1] See Baker Brownell and Frank Lloyd Wright, *Architecture and Modern Life* (New York: Harper & Brothers, 1937).

ancient bulks and shells that litter the earth are
hardly architecture. They are its spoor.

Buildings, on the one hand, are the expression of
a continuous process of construction, use and de-
struction, which is almost metabolic in its rhythmic
symmetry. On the other hand they are also, in the
modern world, active, working machines that give
form and definition to the functions of life. The
heating plants, the stoves, the refrigerators, the
plumbing, the elevators, all the great operative core
of the modern building is an active process in the
dynamics of living.

Buildings have in them, of course, symbolic refer-
ences to action. They have spatial rhythm, form,
mass, and other qualities of matter. These give them
interest and beauty. But most of these are secondary
aspects of activity, symbols, or fixed forms of move-
ment. The stone piers are designed work and effort.
The arches are the spring and compression of build-
ing transfixed there. They point to the action of the
builders and to the continuous action of the mate-
rials that stand there. They point also to the
"metabolism" of buildings and to the active ma-
chinery of living within those buildings. This action
is the primary art. Buildings are records of formu-
lated action and design. They are transmutations of

activity and rhythm into stone. The finished edifice is thus a recapitulation of the activity of building. It is a coda. But buildings are also working instruments now. They are both symbol and fact of movement.[2]

The art of building is not an aggregation of the various activities of the hod carriers, or the steam shovels, or even the architect's activity in designing and supervising. These, indeed, have their part. But the art of building is the organic whole of activity, greater than any one man's comprehension, that creates the structure from a dream, and, in the course of construction, use and wearing out again, creates and re-creates the dream. It is the activity of the building in collaboration with the activity of people in it. Such building has its instrumental or practical aspect, but the art of building is always more than that. It is building beautifully for its own sake. It is a creative process, a formulative activity, compared with which the finished stone edifice is only an incidental summary. It is a testament of work. It is an assurance and a faith in work justified in itself because, indeed, men like to build, use and wear things away in cycle after cycle. As such a covenant, the building has artistic value.

[2] See Douglas Haskell, "Architecture," in *America Now*, edited by Harold Stearns (New York: Charles Scribner's Sons, 1938).

The dead shells of building, Venice, Florence, Ulm, Chartres, Ely, museums, galleries, temples, where action and living function are gone or nearly gone, where bourgeois tourists crowd with shallow gazing, and what activity is there is used to serve them, sell them trinkets, guide them and serve their meals and drinks—these dead shells I would not destroy. But I would put them in their place, the cemetery. For there is no building nor much living in those ancient structures. They are storerooms of life that is no longer life. Where the riveting hammer taps out across the city like a giant woodpecker, where men are active on the job, where life fills the structures with its long dance, building, living, moving, destroying, there is far more architecture as an art than in these cities of the past.

Modern architecture is at last beginning to shake itself free from eclectic antiquities and feeble imitations. It is beginning to express life and the materials that enter into building. Form follows function say Louis Sullivan and Frank Lloyd Wright—and before them Horatio Greenough—and buildings have arisen that express honestly and beautifully the nature of their structural elements and their materials. They are beginning to express also their function as buildings. And it may be in the near future that a steel

and glass railroad station will look like a steel and glass railroad station, not like the baths of Caracalla.

So too, I hope, they will in time express not only their structure, their materials and their function as buildings, they will also express the instruments and activities by which they were built. I would not have a cupola made to look like a power shovel nor a minaret like a riveting hammer, but I would have the quality and action of these machines made expressive in the architecture of the building. It should express its constituent activities.

From America the modern movement in architecture spread to Europe and then came back again. The international style so-called is a product of this reverberation. The clean style of modern city structures, functionally expressive, fairly honest, is one of its results. Other architects such as Le Corbusier, Gropius, Saarinen, have followed with distinction the path broken by Sullivan and Wright. They have their own character as architects, still they are modern. Le Corbusier, for example, as Walter Curt Behrendt[3] says, is in every respect the antithesis and antagonist of Wright. He is urban. Wright is rural. His art is based on an experience in education.

[3] Walter Curt Behrendt, *Modern Building* (New York: Harcourt, Brace and Company, 1937).

Wright's is based on an experience in nature. His art is sophisticated and intellectual, its structure is based on reason. Wright is more mystical, intuitively following elementary laws of organic growth. Nevertheless, both Le Corbusier and Wright, as well as many another, are authentically modern. Architecture may be sensuous, even romantic in the better sense of the word, as in Wright. It may be ascetic, starkly functional and classic-minded, as in Le Corbusier. But in their honesty, their expressiveness of function and material, both are still far superior to the muddled sentimentalism, fake decorativeness and eclecticism of the earlier time. Modern architecture, in a word, like modern music, modern poetry, modern cooking, modern machine design, and many another modern art, is complex and variegated in its character.

X. Painting

PAINTING and sculpture descend from the basic art of architecture as music, poetry, drama and religious ritual descend from the dance. Today architecture repudiates her children, or at least weans them rather violently, with the pronouncement that neither painting nor sculpture has any rightful place in building. And the pronouncement is just. Painting as such and sculpture confuse architectural form and detract from its clarity. They add nothing to the function of building and, when added there, create a kind of grand opera in stone and paint, a mélange of arts without integrity or unity of expression.

If the first modern revolution in painting began with the French impressionists, the second began with the so-called post-impressionists led by Cézanne. The impressionists were scientific in method, though romantic perhaps in mood. They abandoned pictorial or representative art, were interested only slightly in structural form and anatomy, and gave their attention to the perceptual analysis of lighted surface, the skin of light, and to technical experiments in the artistic presentation of it. Thus Monet, Manet, Renoir, Seurat and others developed the "point" system of painting, the textural three-dimen-

sional "surfaces," the composition of color, and other well-known devices of this school.

The post-impressionists are in most respects just the opposite of the impressionists. Like the impressionists they too reject pictorial or descriptive art, but otherwise they move north where their predecessors moved south. Surface and visual purity of surface interest them not at all. They paint not the visual appearance of objects; they give visual appearance to the implicit forms and metaphysical structures of objects which nature does not reveal. They are mystics, or perhaps metaphysicians. The impressionists were physicists, or at least analogous to them. Cézanne, Gauguin, van Gogh, Picasso, Matisse and many other great names mark a school of visual philosophers.

Space may be treated as a function of time and movement, for only by means of time and movement can it be defined in our concrete world. In the world of nature time and space are equally dimensions of events. They are reciprocal and they define each other. But in man, an animal of action, time and movement are more directly relevant than is space. His primary dimension is movement, or action, while space is more or less a derivation from it. Post-impressionism, in this sense, is a fundamen-

tal mode of painting, for it expresses the action of events. I do not mean that Cézanne pictures charging horses or exploding stars. Far from it. He does throw the forms of things, however, into dynamic relation to each other. He creates activity, the strains and stresses, movement and deep rhythm of the real. And this kind of metaphysical action in his pictures —it becomes perceptible as the pictures are studied —is the real.

I am describing something in words which these painters express uniquely in their visual art, and of course I cannot do it successfully. In van Gogh this action of which I speak flames out beyond control. It escapes nature. It is a searing flame in his later work: reality has gone mad. It is a mystic, tragic philosophy not unlike that of Jeffers.

Might not reality be mad? It is a nonsense question I suppose, a semantic nightmare. Might we not imagine, however, that the order and fixation of things that we call real, their sanity indeed, might also swell and change and undergo something analogous to action. Why not? Who said that order is immutable? Might things go mad, and reality itself be crazy? Many people act as if it were, even though they may not think so. These, of course, are fantasies, just philosophical smoke rings. But Jeffers and van

Gogh have made them more than fantasies. Flame, action, terror have burned through. The ivory walls are down. And through a great hole may be seen the smoke and turmoil and mad fire beyond.

The post-impressionists and their artistic offspring, the expressionists, in any case go below the surfaces of the impressionists to what seems to them the essential structure or form. It may be metaphysical; it may be purely aesthetic; it may sometimes be moral or persuasive. The newspaper cartoon, for example, is moral post-impressionism. In any case the post-impressionist uses deliberate distortion of the visual appearance of his subject matter in order to be more expressive of the essential form. Things never are as they look.

Simplification, design in which color and drawing are inseparable, indifference to natural realism and detail or explanatory irrelevance are known as the characteristics of post-impressionism.

In America this movement has come rather tardily into brilliant flower. It is regional in character for regionalism is appropriate to the post-impressionistic effort to find the essential character and nature of a thing. Grant Wood discovers Iowa, Thomas Hart Benton, Missouri. In the later work of Grant Wood there is an almost classic elegance and simplicity.

The curve of a plowed field over a hill, that is all;
or a row of corn shocks in winter! The essentialism,
the paring down, the utter simplicity towards which
post-impressionism may move easily becomes some-
thing analogous to the classical mode of expression.
Grant Wood seems to move more and more in this
direction as his work matures.

In Benton, on the other hand, there is a deliberate
angularity and stubbornness of line, a Gothic em-
phasis and witchcraft. His folk are large jointed,
knobby, not unlike the knock-kneed men in Dürer's
engravings. His lines do not close. His color has an
admixture of Missouri mud. But his pictures are ex-
pressive, defined as Cheney[1] defines expressionism,
not a preoccupation with correct representation but
a search for something in the nature of aesthetic in-
tensification or expressive form. Grant Wood and
Thomas Hart Benton are two of a large and impor-
tant group of American regionalists.

The Mexican group of painters, led by José
Clemente Orozco and Diego Rivera, is probably the
most successful and significant group in any of the
modern arts devoted frankly to propaganda. They
too are regionalists, at least at home, but the spirit

[1] Sheldon Cheney, *Expressionism in Art* (New York: Liveright Pub-
lishing Corp., 1934).

of the Mexican radical revolution is in their work there or abroad. Their best work is mural. Though Rivera is the better known, perhaps for his political opinions as well as his art, Orozco I think is the better painter. Both of them are powerful, massive, primitive. Rivera, perhaps more often than Orozco, is obvious, allegorical and in that sense a painter of representations of ideas, if not of objects. Nevertheless, both men belong, along with many followers, among the post-impressionists.

In the United States, Georgia O'Keeffe and John Marin at the opposite pole of the movement have escaped representationism almost completely. Their work is nearly pure design, and design, it is said, based on unessentials in contrast to the essentialist abstractions of Leger and other Europeans. Often it has unearthly loveliness. But there are many more. The German school of expressionists, before Hitler put a stop to them, had power and intensity. As a culmination, or one of the culminations, of post-impressionism pure abstraction here takes the field. I think it is at least in part a normal evolution in the use of symbols. The symbolists in poetry, the atonalists and others in music, the abstractionists in painting, all emerged at about the same time in their respective arts. Though some direct intercourse and

influence from one to the other took place. I think it is more a result of natural convergence in arts which are at about the same stage of social and artistic maturity. In painting Kandinsky, Kokoschka, Leger and others empty the symbol of almost all its commonality of content. It refers literally to nothing, or to so private a content that no one else knows whether it means anything. Pure abstraction and design are left in this way to become the entire value of the painting. But this is very different from the psychologically simple design and arabesque of the Greeks, Arabs, of the medieval builders.

Where painting will go I dare not predict. The surrealists, Dali and others, would have it go deliberately crazy. They catch the beauty of irrelevant dreams, the aesthetic shock and thrill of disjointed associations and create an interesting artistic episode. In some cases this is sincere psychological realism. More often it is loose fantasy and thrill. Without organic structure on which to build, it cannot go much farther.

The regionalists seem to me to have more of the stuff that is capable of development than any of the others. They are attached to earth. They belong to a culture, a country, a folk that becomes a central expressive content in their work. Their art thus can

have a seriousness of human value that will save them from the swamp of representationalism and propaganda on the one hand and from the thin consuming fires of abstractionism on the other.

The sickness of an art may have two main forms. One is the jaundice of a thesis which is held in spite of human variations and values. Art becomes an instrument for presenting objects and events (representationalism) or ideas (propaganda) and in either case loses its artistic initiative and expressive power. By 1850, says Eric Gill,[2] the idea of "art" had become divorced from the idea of making things. It had come to mean simply the business of making pictures of things.

The other sickness is an anemia in which perceptual symbols are treated as entities distinct from their contents or "referents." These symbols are in turn withdrawn more and more from their "referents" until only the faintest whiff of reality remains, or disappears altogether leaving pure abstraction. Art in this case too loses expressive power because eventually there is nothing to express. It tends towards mathematics. For even the most formal art is the creation of a pattern of activities. These activities

[2] Eric Gill, "Sculpture in the Machine Age," in *American Review*, June, 1935.

are not abstract, cannot be abstract; they are human activities filled with the human gesture, rhythm and peculiar human quality. When art is treated as an instrument without human value in itself, or as a symbol empty of content, this reality and action are lost.

XI. Sculpture

SCULPTURE has been closely correlated with painting in its changes and development, though why it should be so mated I do not know. It is a visual art, at least conventionally. Its products are put in museums along with paintings. But otherwise I see little reason for their intimate correlation. In history, sculpture has been more associated with architecture and city planning than with painting. Sculptured works usually can be left out of doors, on high places, at historic scenes which usually is impossible for paintings. Then, more than all, sculpture is really more an art of the tactile perceptions, of volumes and muscular masses than an art of vision. This difference should distinguish it sharply from painting. It is a difference of great importance.

The age of sculpture that now is happily over—except here and there when the city of Smith's Corners orders a bronze doughboy for the west side park—never really was able to disassociate sculpture and painting. Both were treated as solely visual. Modern sculpture on the other hand is unconsciously, and sometimes consciously, based less on visual perception than on the tactile sense, or the implied tactile sense, and the kinesthetic sense of

mass, weight and volume of bodies. An object seen is different from the same object felt with the hands, and sculpture that may look funny to the unsophisticated eye may become entirely intelligible when considered from the tactile and kinesthetic point of view.

This I think is an important element of modern sculptural expression. In the work of Archipenko and Brancusi, for example, simplification is a tendency towards a more tangible art. Their productions not only are based on "touch" forms, they often are plastically modeled as with the hands rather than carved or cut with a chisel. Sculpture in this sense becomes an art of action. It is muscular, tactile, kinesthetic, and in much modern work this kind of activity is expressed. The visual aspect of it were better forgotten.

I am assuming in this discussion of the arts that different functions and modes of human activity have their own forms. Visual forms and values are different from sound forms. Muscular forms, which underlie all of them, have in turn their own values. Touch forms again are different from those peculiar to vision or sound. Though works of sculpture are usually seen, not touched, at least according to the admonitory cards in museums, they still may express

the tactile and muscular functions and forms of living activity. A more direct and fundamental art might involve actual touching and modeling activities by the spectator as well as by the sculptor, but this is hard to ask of all enjoyment of this art. An Apollo Belvedere, for example, is primarily visual sculpture, and to modern people seems weak, very likely, and pretty because it fails to express the qualities of its stone material and the muscular modeling and tactile activities involved in its creation. It sings, or tries to sing, something not suited to its natural voice. It employs a perfected technique to cover up rather than to reveal the essential activity that sculpture must always be. Classic art in its decadence does this. Probably other schools of art decline in the same way. Archipenko's figure called "Repose," on the other hand, reveals the forms of tactile and muscular action and the shaped, modeled stuff of which it is made. It is an essential form and metaphor of repose, but repose expressed in stone by hands that work and feel. Eric Gill, again, brings sculpture back to stone. It is work on stone—if that be the medium— and men who design for stone but leave the cutting of it to hired hands, he says, do not deserve the name of sculptor. His work is rounded, massive, blocklike,

stony. It is work on stone. Rodin, Michelangelo, and before them the Egyptians and the primitives, knew something of this principle, but it remained for modern sculpture to develop it.

But modern sculpture, with all this, is also expressionistic in character. There are Maillol, Lachaise, Manship, Gaudier-Brzeska, Epstein, Lehmbruck, Meštrović, Borglum, G. G. Bernard, Barlach, and many more, who have realized the implications of the post-impressionistic revolution, and repudiate more or less the older representationalism of art. The wood carvers have returned. Some work in the new metals and plastics is being done. Gigantic work at Stone Mountain and Mount Rushmore has been carried out by Borglum, who carves mountains with modern drills and dynamite as another might carve a block of marble in his studio. All this is interesting and valuable. But modern machine design and the plastic arts of giving form to industrial machinery and instrumental equipment has as much significance, I think, if not more, than all the work in conventional sculpture. Perhaps it is not sculpture, this formulation of materials in volume to suit beautifully their function. It might be better for the art of sculpture if it were.

The Climax of Three Arts

For sculpture, painting and to a great extent the printed word have reached their climax as arts. As conventional fine arts, they become ever more a superimposition on life and less a functional and significant activity involved in living itself. They become an aesthetic addition, a pleasant luxury, if life can afford them, but not deeply involved in our essential action. Though I like to have about me these traditional luxuries, I doubt if they are as pertinent as they once were. Other arts and developments tend to supersede them. Like Britain's monarch they are more of a sentiment and a symbol than an active, functional part of the organic situation.

Though architecture, music and the dance retain their primordial importance as arts in life—nor do I see how they can well lose it—painting, sculpture and the written word as arts become more a cluster of supernumeraries. Perhaps I am wrong, I hope so. Much that I have said before tends to deny what I am now saying. Perhaps the expressive needs of man now and in the future will continue to find necessary these particular methods and materials called the arts of painting, of sculpture and literature. But much has happened technically and culturally. The movie, the radio, travel, photography, the wide-

spread ownership of dynamic machines and equipment, design in moving machines, and many another thing, and above all a restless jittering of psychological phenomena, crowd heavily upon pictures, blocks of stone, processions of words. They crowd them, not merely as consumers of time and attention, but as arts. In consequence sculpture and painting, if not literature, have been forced into more and more esoteric fields. They turn to hectic brilliance as a fading woman turns to vivid clothes. They struggle for survival. There is little doubt of it. They struggle as they rarely have had to struggle in the past.

I would like to write a book, were I able, in which the values and interests in life that are variously called consummatory, aesthetic, participatory, spiritual were given their true proportion and assignment in things as a realistic observer would discover them in the modern western world. In such a book the informal and unrecognized arts would rise in emphasis, I think, while some of the traditional fine arts would sink almost to extinction. History and habit give them an importance both spiritually and socially that they no longer really have.

XII. Costume

But if sculpture and painting get attention mainly from a few professionals, students, and elderly, unoccupied ladies, the art of costume has world-wide appeal. Costume is a minor art, to be sure, but seems to be always with us. To most men it is something of a trial to be borne with fortitude, or at least so they pretend. But to woman it is expressive of her very value, as she sees it, and her hope for happiness. If those who practice the formal arts are in most cases men—in contrast to those who listen and look—in the art of costume women are the practitioners.

For costume is an art of action. Costume is "worn," and the wearing involves a set of human activities that ranges from childhood to old age. Costume, indeed, is a way of giving living actions distinction and emphasis. Apart from the gesture, the pace, the movement, the physical nuance of the person in it, costume is meaningless. It gives status to human actions, and though many of us feel that it plays altogether too large a part in the classification and intensification of human behavior, few of us can deny its power. Imagine, for example, the head of a great financial partnership in Wall Street appearing at a directors'

meeting in blue bloomers, or the queen mother of a great empire in a merry-widow hat. The mere thought shocks us. But these matters have been discussed by Carlyle.

My concern here is the sad state of modern man in the art of costume. That woman will be more progressive in dress than man may be expected. It is her art, and though extravagances in costume still appear ever anew while hideous traditions such as the French heel survive, her dress in general is far more comfortable, more beautiful, more sanitary and adaptable than is man's. She has adapted her clothes to her new activities. She has adapted them to the warm interiors of American buildings, with light clothes, free neck, arms, ankles, and a heavy outer coat for out of doors. She wears few or no clothes in contact with the skin that may not be changed and washed daily. And she uses color, line and design in infinite variety and grace. The French heel, to be sure, remains a curse to graceful carriage. The high heels thud and jolt along the sidewalks. The cheeks shake, the breasts shake, the body lumbers and hops. On our tall, slender-legged American girls the French heel, planned to make the short, thick-legged Latin type look taller, is nothing less than an atrocity. But all in all women's clothes are

expressive of their modern life and of what they want to be.

Man's clothes are another matter. No revolution here has blessed him, unless it be the French. It took the French Revolution, indeed, to get his breeches off and to make long, workingman's trousers common. Since then little or nothing has happened to men's clothes. They are neither functional, sanitary, nor comfortable, and their conventional ugliness is a sour smoke over the life of man.

The key to men's clothes, as I have said elsewhere, is the shirttail, though the metaphor may seem somewhat mixed. As the shirttail goes, so goes the whole costume. Western habit in recent decades has been to tuck it inside of the trousers. From this follows a long series of sartorial misfortunes.

With shirt tucked in, the northern frontier of the trousers becomes visible with all its belts, braces, pockets, buttons and other gadgets. It establishes a waistline, moreover, altogether too high. In English trousers indeed the waistline rises to the armpits. With all this the shirt bulges and flaps always needing readjustment, or tucking down, after every movement. All in all a man in his shirt sleeves is definitely not fully dressed, and he knows it.

In consequence well-dressed men will not appear

in public or elsewhere, if they can help it, in shirt
sleeves. The coat becomes a necessity in summer and
winter. But the coat requires a shirt collar that is
closed and high, with a tie to give it finish. On a
hot summer day the well-dressed man on the city
street has no less than seventeen layers of cloth
around his neck (count them), five or six layers
around his upper torso, six or seven layers around
his belly and buttocks, five around his ankles if he
wears cuff trousers, three around his arms. His
shoulders are padded with wadding and haircloth,
and he issues into the heat of a continental summer
swaddled and swathed in fold after fold of cloth. His
suits of tropical wool cloth (proper for business) are
rarely cleaned more than once a week, and for most
mortals not once in six weeks. They stink with sweat
after a few days' wear. They are gritty with the grime
of the streets. That men in a modern age will tolerate
such clothing indicates, to say the least, an insensi-
tivity and a stupid fear of change that is alarming.
Can a worth-while new world come of such a herd
of asses? It begins to seem doubtful.

The key to this situation, as I have said, is the
shirttail. With it in, the above situation is inevitable.
With it outside, a way to progress is open. There are
today numerous garments serving the function of a

shirt which are worn outside of the trousers. The hunter's jacket, the sailor's middy, the workman's jumper and the modern polo shirt are such. If one of them, say the polo shirt, can be translated into ordinary street wear, for business, pleasure and even "dress," the problem of men's clothes will be on its way towards a modern solution.

And for the following reasons: Such a shirt worn outside will give a man a sense of being completely dressed even though he wears no coat. A coat or its equivalent, indeed, can be carried on the arm, as a raincoat or overcoat is carried now, to be put on or off as comfort requires. With an outside shirt but without a coat, the waistline will be where it belongs, fairly low. Buttons, braces, pockets, gadgets, as well as minor bulges of the belly will be effectively screened. The shirt will adjust itself naturally to movement. It will fall straight and close about the hips without the ballooning, flopping, twisting, wrinkling of the tucked in shirt. It will be cooler than the tucked in shirt and give better ventilation.

With the outside shirt, moreover, the coat will become only an accessory garment, unnecessary in our well-heated houses. The absurd waistcoat will disappear. This will permit in turn an evolution of the shirt collar and sleeve. Sleeves may be short, if de-

sired. The collar of the shirt may be tailored open at the neck, if the wearer wishes it, allowing ventilation and sunlight for that important bit of anatomy. Or better, the shirt collar may be left much as it is now, so that the man can wear his coat or leave it off and in either case have a shirt suitable to his needs.

The new shirt, furthermore, will without doubt have its influence on the trousers. Some kind of long trousers will probably persist so long as we live in great industrial cities. Though at best they are an ungainly garment, nothing much can be done about it so long as man remains the crotched, forked, two-legged creature that he is. Robes, tunics, à la Raymond Duncan, are out of the question in street cars, automobiles, factories, elevators and crowded buildings. So also are shorts. It follows no doubt that trousers we shall have always with us so long as urban civilization persists. They are one of its penalties. But they need not be built like a battleship, fitted like steel plates riveted together. They can become cloth once more and hang like cloth. The new shirt, I say, may well influence the future of trousers.

As to pockets, the average man, who now uses his waistcoat as a kind of desk, full of woolly pigeonholes, can have pockets in his outside shirt, four of them,

or carry a brief case especially fitted to his needs, or wear a pouch at his belt after the manner of Natty Bumpo, the Deerslayer, and his victims, the wicked redskins. Provision for pockets can easily be made. In any case the pocket has altogether too large a place in modern civilization. It indicates a minute instrumentation and compartmentalization, a smug secretiveness of little possessions in modern life. A life which needed no pockets would be better.

I had once about given up hope of reform in men's clothes, nor am I optimistic now. Still there are important and favorable signs. Years ago I had made for me several shirts of the above type and wore them with courage and credit on various occasions. Several of my friends, a famous cartoonist, a columnist, a retired capitalist, an athletic trainer, a streetcar conductor, a manager of a large concern, a down-town tailor and others adopted them. We were a brave little band with hope in our eyes. But none of us had met the then Prince of Wales, nor were we students at Princeton; and we could not get our project adopted in a big way. Hope simmered down to hardly a bubble.

Then from nowhere, seemingly, the polo shirt came in. It was photographed at Palm Beach, at Hollywood. In a year or so it was promoted by shops

and haberdasheries and, among others, by one great department store that had once ridiculed in advertising our pioneer efforts. Variations of the polo shirt, the planter's jacket, the bush jacket, the coat-shirt, the sport shirt, appeared. In a year or so the prejudice against shirts with their tails out disappeared. Now they are worn rather commonly.

But the victory has not yet been consolidated. What is now a fashion mostly for sport and resort wear may be segregated permanently in those fields or it may disappear, as fashions do. Until the outside shirt is confirmed as the usual garment for summer and for indoor wear, with the coat as an accessory, there can be no certainty that the salvation of man in this respect is more than temporary. What native intelligence he may have is not very effective in matters of costume. I welcome the new but keep my fingers crossed.

The radio roars and chatters through my window day after day, and I wonder sometimes how this constant immersion in "music" will affect the life and culture of people. A life thus dressed in music as continuously as in clothes must be affected, but I don't know how. As for clothes and the art of costume, they are closer to us in several ways than any other art. The effect of them daily on us, on every

gesture, on every movement is incalculable. We have become, in fact, essentially clothed animals, and unless the new and wholesome nudities of the beaches and athletic fields can save us, our clothes may eventually smother us. That is a fate for a race, indeed, to be smothered out like a small fire by its own clothes!

XIII. Modern Tendencies in the Arts

I HAVE discussed nine arts, the dance, music, cooking, poetry, drama, movies and fiction, architecture, painting, sculpture, costume. At least ninety more are left, for the muses are a large congregation. I have dealt with these nine as aspects of the consummatory activities of men. These in turn are treated as part of the dynamic activities of the man as contrasted with his nutritive activities and his symbolic activities. But what of the arts in general? What common characteristics and changes do they show in modern times?

Most of the arts have two tendencies. One is towards folk and regional art, occupational and craft art, and nativism of some sort. Art with this tendency is diffused and informal. The amateur has a large part in it. It is often rural or small town in type, mystical or unconsciously rhapsodic in character. It is humane. The other tendency is intellectualistic and ultra-sophisticated. It is usually cosmopolitan, urbane, often exotic, alien. It is complex and specialized and is in the hands mostly of professional artists and critics. Novelty, technical perfection, professional execution, rationalistic development mark it.

It is relatively indifferent to those things usually called humane, and entirely indifferent to regional interests.

The misfortune of the modern arts is that these two streams of art flow ever farther apart. Their separation comes from the fact that modern urban and academic culture becomes ever more cosmopolitan, ever more indifferent to the native roots and regions in which it spatially is situated. Because of this disastrous separation our native arts are a vast greenery but without the flower and development that they might have. The sophisticated arts, on the other hand, wither as they grow. They have no juice.

It is true that these tendencies in art may be constitutionally irreconcilable. Modern sophisticated art is antagonistic to regional development, cuts it off, supplants it wherever it gains ascendancy. Whether it be the academic criticism and scholarship in the universities, or the artistic affairs of great concert halls, opera houses, galleries and so-called cultured sets of the cities, whether it be life in the clubs and fraternities at college or in the clubs or apartments in town, the tendency is always to wash away the native color of people and places and to lay on a varnish of common cosmopolitanism, or "smartness." But if modern cosmopolitanism can contribute little

to regional art, the intelligence, taste and skill that enters into it could be of great value. This intelligence is not necessarily a peculiar mark of abstract urban culture. It could well be directed towards the sources and grounds of all culture, namely, the unique life of people in places. It is, indeed, largely a matter, not of ideas, but of personnel. A procession of men marches into cosmopolitan art, men who could be of shining value in the service of their own folk.

The movement of sophisticated art in all fields is in general towards abstraction. Violent reactions to this sometimes result in schools of artistic propaganda, but, on the whole, greater and greater abstraction, mathematic, psychological, verbal as the case may be, is the outcome of professional, sophisticated art in modern times.

The decline of absolutes and of absolute standards is another tendency not only of this sort of art, but of all art. Though absolutes too are abstractions, they are not flexible abstractions. Their decline may be observed in almost every field of human interest. Provisionalistic thinking, mystical participation, or a fevered search for new standards characterize not only most of the arts but other fields as well.

This decline of absolutes should be welcome for

the most part. In a world undergoing so violent a change as this one now is undergoing old standards and criteria of value are bound to be inadequate. They too change, not to new absolutes in substitution for the old, as the communists, fascists and other totalitarians assert, but to flexible, provisionalistic, experimental patterns, which are continuously adaptable to the pace and change of a modern world. I say this knowing that men such as A. J. Penty, Graham Carey and Eric Gill would no doubt attribute the current notion of art as a specialized product produced by a unique specialist, or genius, to the relativism of the Renascence that displaced the absolutism of the Middle Ages. I admire the attitude of these men in repudiating the "specialist" notion of art, but I do not think this "specialism" arises from modern relativism in thinking. On the contrary, modern relativism, at least as I see it, leads away from such specialism. Though I accept in my own point of view what may be called a mystical absolute so far as it refers to the primitive and appreciative integrity of living, this in no sense is the external, authoritative absolute of the Middle Ages. Modern art will not find integrity with life in these medieval absolutes. Modern art is—or should be—related flexibly to living and in living. The structure

of that relationship is modern relativistic or provisionalistic thought.

This new provisionalism in the arts, in science, in social theory is the only mode of approach to modern situations that is adequate in the long run. Only that is capable of exploring and developing the great potentialities of human life and the material resources and power that are available in these times. Unfortunately the arts have been little aware of it. They have moved unconsciously in these directions or they have dodged, in an almost frantic search, from one fancy absolute to another—for the most part soiled revivals of old authorities—looking for peace and certitude. But certitudes cannot be manufactured nor selected from ancient shelves, nor discovered by joining the party or the church, even though a T. S. Eliot, a Scriabin, or a communist convert may feel that the time has come when he needs one.

XIV. Art and Symbols

IF ART is action, as I have said, how can it be reconciled to the use of symbols? I am frank to say that it cannot in my opinion be entirely reconciled to symbols. Art accepts symbolization, as it were, though symbols are its deadliest enemy. It uses them because it must in order to increase its range and richness. It uses them because it must in order also to be socially communicable in a world where masses of human beings are associated more and more by metropolitan abstractions and anonymous, landless ties. For the symbol is an invention to provide indirect experience. It is a secondary activity. Art, which in essence is direct activity, finds in the symbol a most dangerous instrument. Nevertheless many of the more mature arts are symbolic.

Symbols are man's greatest invention. The creation of them and the manipulation of them in chains of symbolic relationships sometimes called thinking is a unique activity in man that gives him what superiority he may have over other animals. A symbol is a token conventionally established to designate something else. It is in itself a small activity such as a spoken word, a letter written or read. It is a simplification of activity, or substitute for it, which is

manipulated as a unit having a character of its own.

This activity of manipulating symbols, picking and choosing, placing them in various sorts of chains or in other relationships with each other, is in itself not different in character from other activities, such as picking and choosing in a pile of jelly beans in order to get the licorice ones. But the manipulation of symbols is unique in that the symbols are used not as objects or events in themselves but as simplified references to objects or events not usually present in experience. By means of symbols a man in thinking can refer to things not present and because of that can act in reference to things not present. The manipulation of symbols is thus a peculiar condensation of activities. It is an activity referring to whole areas of other activity. It is a piling up of activities that enormously increases the range and reference and indirect experience of life.

Thinking is thus a device for expanding human range of action and control. It is an economy from this point of view whereby range, diversity and power are increased at the expense of concreteness and the immediacy of experience. I think of a ship rather than go down to the sea to look at one or to operate one. I think of all the ships in the harbor,

or all the ships in all harbors, and I get total tonnage figures. The concrete experience of the ship more or less disappears. In place of it I have a simplified and stereotyped little package called the word "ship," or a picture of it, or the smell of it, or the design of it. This, or something like it, is my symbol referring to the actual ship. In place of direct experience I also obtain a range of "knowledge" about all ships, and a certain abstract characteristic of them, that would be quite impossible without the economy (or condensation) of symbols.

But the wide function of thinking and the overwhelming significance of symbols in modern life should not make us forget that the symbol itself is only a peculiar sound called a word, or a complicated mark on paper or something of the sort, which we choose to use as a substitute in our activity for the event or object to which it refers. In itself it is nothing but the little sound or little mark, and all the majesty of ideas and of "meanings" comes down to this. Meanings, in other words, are not some realm which has authority in itself; they are the references by symbols to the activities and events for which they are substitutes.

This act of substitution might well be the subject of long consideration. So too might the relationship

established between different symbols, which is called logic and grammar. So too the referent, or the object referred to by a symbol, whether it really is referred to, or whether there is anything to which the symbol refers, might take many lifetimes of investigation. For this would involve semantics, science and even metaphysics. But these great matters can only be touched here.

Symbolization is a system of substitutes for action, often piled high on each other, that is itself a kind of action. It advantages mankind in giving him greater scope and control of activity. But it is indirect. It sacrifices the poetry and concreteness of living, and indeed the religious integrity of it, to the extent that abstractions, remote, indirect experience, and substitutions replace the immediate presence and moment of life.

This process of symbolization I shall call, for want of a better term, a kind of neural activity. And just as nutritive activity includes neural and muscular action, and muscular or overt activity includes nutritive and neural action, so this specialization of neural activity is not by any means only neural activity. Nevertheless, the process of making and manipulating symbols is no doubt mainly an activity of the nervous system, or at least I may call it that.

This, of course, refers not at all to the contents of symbols and to the symbolic relationships of those contents to each other. That is another matter. It is logic, science or what have you, and relates, according to one's metaphysical position, to a realm of events, objects, activities more or less independent of our perceptions. I refer of course not to the content but to the activity of using sounds or marks as symbols, and to the memory and manipulation of them. I refer to the perception of those symbols, and to the conditioning process whereby they are attached to some "referent" and acquire meaning, to the memory of those meanings, and to our shuffling and reorganizing our assemblages of symbols. All that, or thinking, is presumably neural in one way or another.

I wish that I might make more clear this difference between the activity of symbolization on the one hand, and the contents of symbols and their relationships on the other, for here lies the long trouble in western thought over the problem of mind and body, or the incommensurability of physical activity and "thought." The difficulty may not be so great as it has seemed.

Thinking is an activity mainly neural in character. The content of thought, or the referents of the sym-

bols used in thinking, on the other hand, is events, objects, activities referred to but not present in experience. Thus little activities, or the use of symbols, stand for larger activities or the content of symbols, and man's range increases correspondingly.

These larger activities, such as the battle of Lake Erie or the irrigation of the lava plains of eastern Washington, are not actually present in my experience but by means of symbols I treat them as if they were, and the results are astonishing. I have by this method *comprehended* these remote events indirectly in my experience.

The mysterious dualism between mind and body, that so long has pestered us, does not raise its head (or heads) when thinking is seen in this light. For the difference between mind and body becomes only a difference between indirect or substitution activities and direct activities. When thinking as a process of symbolization is considered in this light the problem is not so much solved, it simply does not appear. But in any case the solution of this long and hard problem, if a solution be necessary, will lie in this direction.

What is the character of this neural action from which symbolization, or thinking, emerges? Into those amazing labyrinths of neurology I dare not go.

But certain obvious aspects of the process, or seemingly obvious, may be pointed out. Thinking involves perception of the symbol, say the word "raccoon," and the recognition of it whenever it occurs in conversation, or in dreams, or in silent conversations with oneself, or in reading. Thinking involves also a more or less formal process of learning, or conditioning, in the past whereby this word or symbol is now referred correctly to the actual raccoon or to experiences that bring raccoons to mind. It involves also the memory of this correct reference and at least some of the associated events, emotions, reactions that would be attached to one's experience of a raccoon were it present. Thinking thus involves the use of the word or symbol in lieu of the actual experience of the raccoon. This symbolized experience of the raccoon is to be sure much more simplified and more easily manipulated than is the raccoon itself. That is one of its advantages. Thinking calls this pseudo-raccoon or symbol into the present where it is associated with other symbols or pseudo-events, objects, activities, and the process of thought goes on.

The point neurologically about all this is that nothing in the thinking process, as far as we know, is other than activity. For the symbol, as I have said,

is a little activity, sometimes called a tacit activity, which by convention stands in lieu of larger or more remote activities. These little activities in turn are joined with other little activities in the process of thinking to make up the entire structure of thought. Nor is "consciousness" a reality of a different realm, from this point of view. Consciousness is merely the total complex of these activities frozen, as it were, in their momentary relationships for purposes of inspection, philosophy and general sentiment.

For the components of the thinking process seen in terms of symbolizing activity show no signs of being other than activities of our neural system. Sensation and perception are capacities of the nervous system to be affected by details in the environment and to elaborate those effects in certain ways. Learning is a process whereby the reactions to stimuli received in sensation and perception are given certain repetitive patterns. It is called conditioning. Memory is the capacity to fixate and to reproduce in part these perceptions and their associated patterns. Nor is the substitution of the symbol for the direct experience and the association of it with other symbols anything that may not have a neurological basis. Thinking, in short, is a process of much elaborated secondary experience and must be con-

sidered an integral part of the organic pattern of activities of the human body.

Enormously complicated it is to be sure. But if one distinction is kept clearly in mind, the problem has no greater difficulty than many others. This is the distinction between the activity of symbolization, or thinking, and the content of thought. Confusion of these two aspects of the situation not only by ancient and medieval metaphysicians but by modern scientists and philosophers has caused more intellectual disaster than any one kind of muddle-headedness to which our civilization is heir. For between the activity of thinking and the content of thought there is simply no operational relationship. This too often is forgotten.

Does the Queen of Hearts, for example, the strange two-headed lady who lives in that nowhere behind the bridge card, act upon things or move things? Does the gentleman referred to by the word, Washington, have himself any active part in all the oratorical processes in which the word is used? He is only the referent of a symbol. He himself is not here. In spite of Plato and the primitives before him and many thousands since who find some magical identity between the symbol and its referent, the referent of a symbol, or object to which it refers,

obviously has no relation to the actual physical symbol or to the activity of symbolizing other than that it is referred to. The content of thought in other words does not enter as an activity into the neural process. It would be a world of utter magic and confusion if it did.

The symbol as I have said is a little activity that is arbitrarily made to stand for another activity not present in experience, and though we act more or less as if it were there, that does not make it there. We act upon symbols or interact with them; we string them together and manipulate them in a way that seems appropriate to the character of whatever they symbolize; but we act only on the symbols in our thinking not on their referents; and only the symbols in things, not their referents, act upon us. When we act upon the actual things referred to by our thinking, then thinking is over and we have entered the world of overt action and events.

Thinking, indeed, is a kind of experimental preliminary to overt action. It is a way to economize our action, a way to make our mistakes in private and to learn better without paying the penalties that those mistakes in action and events would bring. It is an evolutionary device whereby a kind of secondary experience of enormous range is provided

without the corresponding cost in overt action and in mistakes that such expansion otherwise would entail. And by this device man has conquered.

Inventing the Future

In my discussion of the arts I have indicated that this symbolized or secondary experience is somehow inferior to more direct action and experience in action. And from the point of view of art and religion this I think is true. For symbolic thinking is primarily a practical device for expanding the range and power of man. In its nature and process it tends to disintegrate living action as a whole into special and isolated functions. It forsakes the consummatory values and concreteness of overt action in order to establish useful abstractions in dealing with events. It segregates living value and focuses attention on certain devaluated essences, abstractions, universals that are easily manipulable.

Above all it invents the future through the instrumentality of symbols and starts all that strange train of baggage called postponed rewards, produc-

tion for future consumption, Pilgrim's Progress, and the like, on its sad course towards civilization. Though human activity, as the Freudians and others say, has in it an element of purpose or drive towards an end, which gives character to its dynamics, the invention of a symbolic future with all its consequences in substitution and indirect living is something else again. In Nature the future is implicit, to be sure, but it remains implicit. In a more civilized and artificial life it is explicit. It is made articulate, external to our action. It lies heavily on us.

I grant, of course, that it would not be wise or practicable to abolish the future. Still at best it is a misty tyrant whose greedy ration is symbols, gas, fogs that smother us and chill the present glow of living. For the future is a symbol, a big word, little more. What does it symbolize? What does it refer to? Certainly no one has experienced it or acted on it. It has no bone or juice. The future no doubt refers to our capacity to spread thin or ignore the fullness of life, to separate its functions, and to sacrifice consummations and intrinsic values in order to aggrandize the productive and instrumental aspects of our activity.

The future is possible only in symbolic thinking, never the concrete. It is opposed to art and to what

I call religion. Its inventor no doubt also invented civilization, but the cost was great. The integrity of life, wherein activity is at once producing and consuming, or enjoyable, in function, has been lost as a natural and expressive rhythm. It must now be acquired, if obtained at all, by deliberate effort and consideration, namely, by art. All this has the invention of the future done to the arts and to religion.

But the more symbolic arts such as poetry, drama, some music, painting, nevertheless do pretty well. We have been so long immersed in symbolic, indirect experience, that the substitute has a good deal of the thrill and fire of the original and in addition has a scope and character of its own that the original may not have. A little girl may love her dolly more than she loves real people. A little boy may have a better time with his blocks or toy wagon than with real buildings and moving wheels. For the real things are stubborn and recalcitrant. They are less amenable. They have wills of their own that rebel against the easy power and manipulation with which we deal with symbols. Though a mature art or religion can hardly be based on the pleasure of escape from the real, the factor of escape is no doubt a strong one in much symbolic art as well as religion.

There are other aspects of the symbolic arts, however, that give them interest. Folks can and do love anything, if they put their attention on it, and even symbols of something else have a body of their own, a jet of sound, a line curved, an intimation of rhythm and textural beauty that they may love. And they may make of it an art, such as calligraphy or arabesque, that is shallow, to be sure, without the deep vitalities and burden of action or the range and discursiveness of symbolic content; nevertheless it has charm. Good poetry, music, drama, fuse all this into the action and the symbolic brilliance of their art, and make them all somehow expressively one. But such arts are like the nitrates in chemistry. They easily break down, sometimes explosively, and become different but more stable compounds.

Beyond all this the symbol itself, it must be admitted, may have an imaginative consequence and intensity that gives it status as a more or less valid object of appreciative expression. Usually this is a symbol that has no observable referent, such as Eternity or the Class Struggle, but it becomes, nevertheless, or it may become, the focus of imaginings and intense expression that gives unity of a sort to life, at least a fictional unity, and formulates in

a glowing whole life's activities. Though art or re-ligion like this has to me a desperate kind of artifice and made beauty that defeats by its pathology the naturalness of art and religion in a sane world, still I must accept its sincerity and occasional power.

XV. Art and Religion

From the arts to religion is a short step that still is immeasurable. For religion is not a detached consciousness or contemplation but the appreciative integrity of our action itself. It is like art in its mystical participation in whatever may be real. It is unlike art in having no medium, no limited range of perception, no created object or work except life itself. This medium, this range of perception, this created work is life in the sense that life is a focus of activities in which we find, or make, unique value.

And because religion is concerned less in the intrinsic values and forms of stone or sound or muscular movement and more in the values of living as an integration of activities, it seems less objective. Intangible it is. Religion cannot be touched, seen, smelled, heard. But just as art is neither objective nor subjective, so religion is neither subjective nor objective. Both are mystical in essence, or in this sense, spiritual.

I once wrote a book[1] in which I tried to express this essential mysticism of religion. Today I would not change the book greatly but I would add em-

[1] Baker Brownell, *Earth Is Enough* (New York: Harper & Brothers, 1933).

phasis to the dynamic aspect of the religious or appreciative life, for at that time it was less clear to me than now. I would try to make strong the point that religion is never abstract, never self-contained awareness, never "consciousness," or as it often is called "contemplation." In the dance, for example, awareness or contemplation is only in the dancing itself. Cleavage there between the contemplative and the active is impossible. So in religion I would like to abandon, and see others abandon, that disastrous duality between living activity and the contemplation and evaluation of it. For in religion as well as in the arts the mystical identification of value and activity is the essential thing. This is the primordial identity that I call the real. The cleavage between them is a sophisticated, artificial tendency that destroys not only religion and art, but the essential integrity of life itself. Religion in other words is the appreciative or consummatory aspect of human activity as an integral organism.

But enough of these concepts and pseudo-concepts of religion. The mind, concept maker, as such is fundamentally non-religious. It promptly leads the attention to other things. For religion is not knowing or classifying, but seeing, doing. It is an insight. It

is concretely in our actions, a brilliant and vital sense of their importance in themselves. It is direct, concrete, active. It throws all life into this immediate presence of being. I feel rather helpless using words. I can only point to the fire within life, and say, "There it is. 'That art thou.' "

From this point of view the postponed values that mark most institutional religions and the postponed rewards promised by them and by modern business, industry, education and indeed our entire culture and profit system, are excellent examples of what religion is not. Systems of value in which the present is treated as a preparatory testing ground, or a sacrificial labor for something that is to come, defeat the integrity of life. Granted that the development of a civilization requires to some extent the subordination of present activity to the demands of the future as a practical necessity, it does not require the idealization of such a pattern as the structure of a good life. This invention of the present and future as separate functions of life, for that is what it really is, with all the prestige and essential value located in the future, is a disintegrative tendency that through the centuries has verily brought our western civilization close to ruin.

This may seem an overenthusiastic criticism of the traditionally western expression of religion and the appreciative life, but it is not too strong. This postponement of values, this tendency to give the concrete present of things the status of an instrument without value in itself and the abstract future a primary virtue as the receptacle of all rewards and things worth while, is characteristic of all western culture. It is characteristic, indeed, of both great wings of our Aryan thinking, the Indic and the European. It is fundamentally unreligious. It is separative, abstract. It destroys the concrete immediacy and integral value of living action.

I wish that the full meaning of that reiterated phrase of the thirteenth century mystics, "God is within you," might be more deeply appreciated by people in churches. Its meaning today is an appeal not to the supernatural, not to external personalities and powers, not to cosmic mathematicians. It is a simple recognition by those gentle seers of six centuries ago that the immediacy and presence of our lives contain all that there is of value in them, and were Meister Eckhart living today I think that he would say so. In life are the values of life. It seems simple and obvious enough. But the modern world

industrially, institutionally, theologically is constructed to defeat it.

Religion, I suggest, is integral activity. It is valued living. And art for any human being is practiced art. Art is action.

The End

Index